THE WATERCOLORIST'S
GUIDE TO PAINTING
TREES

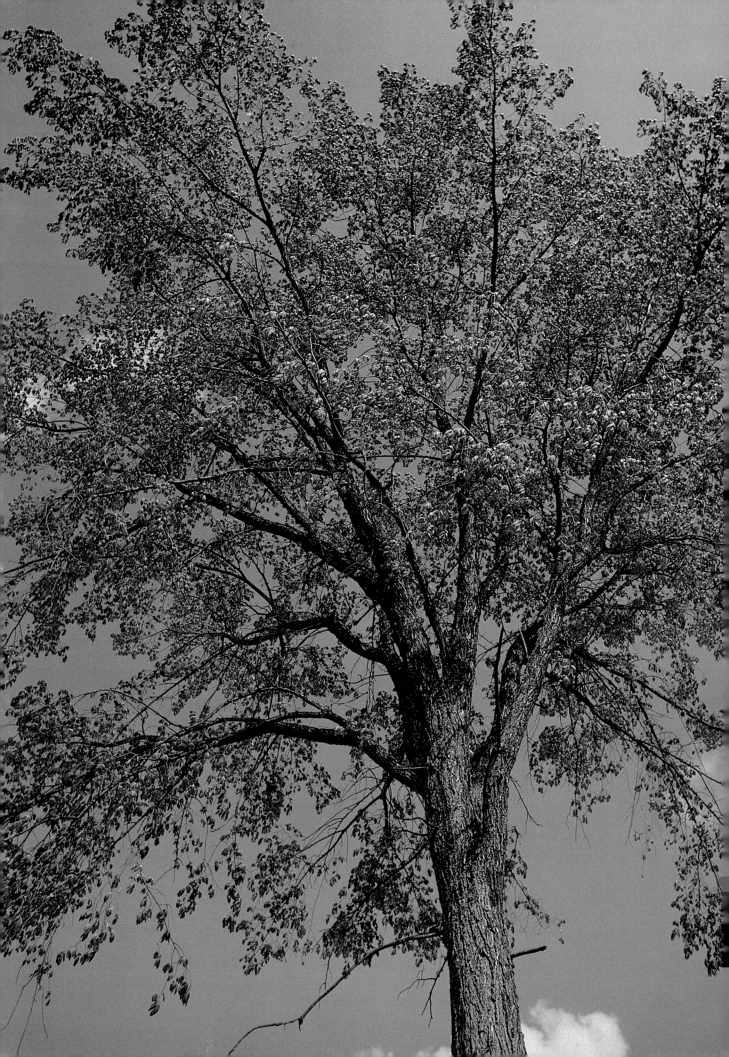

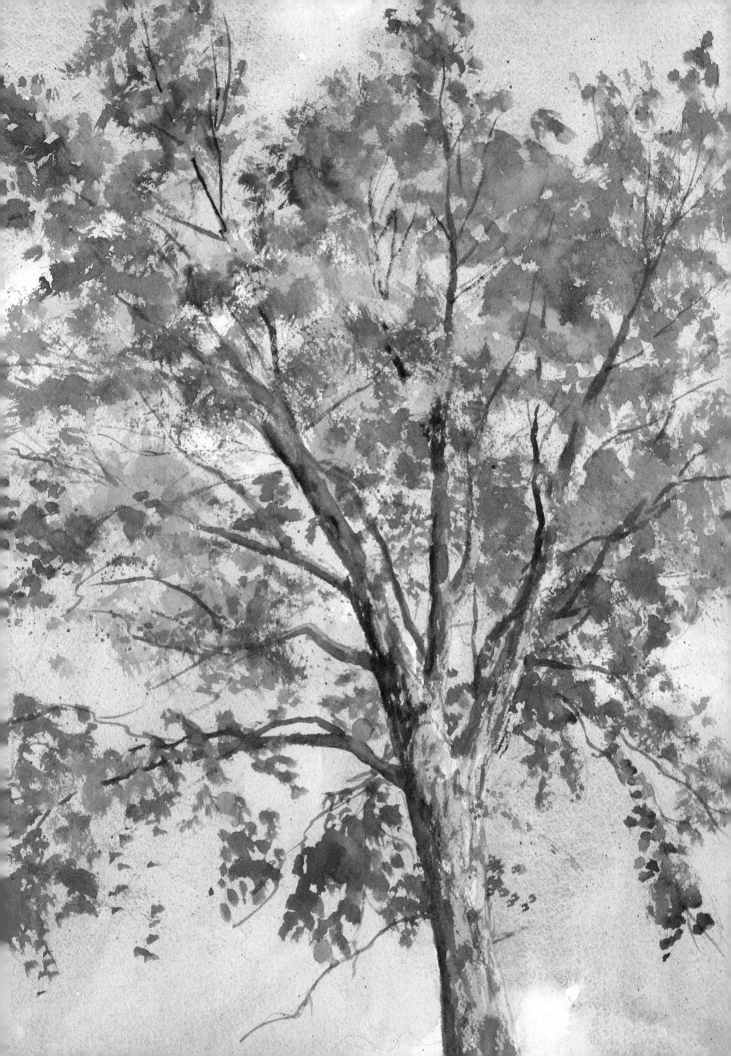

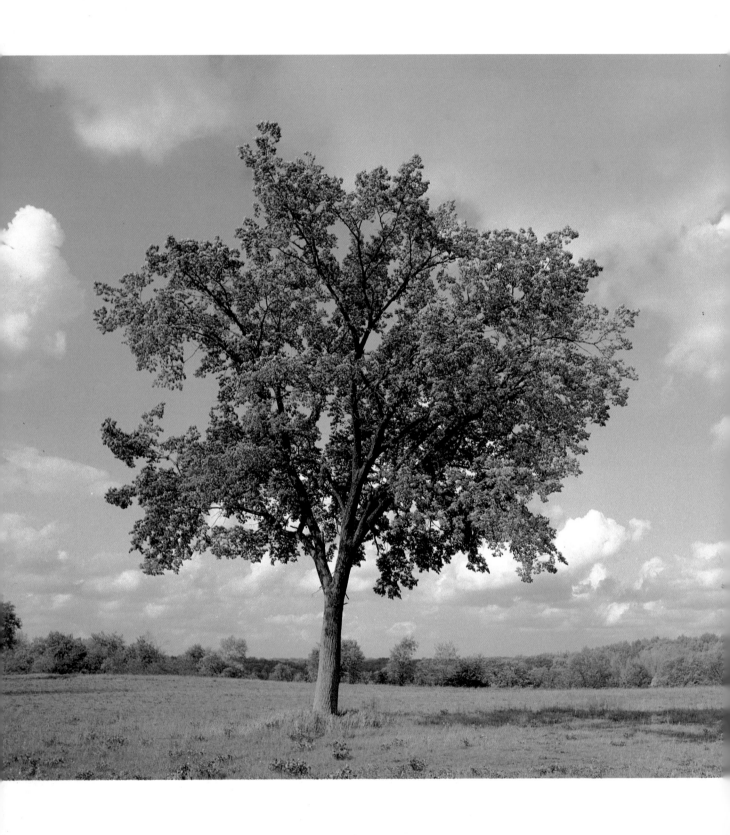

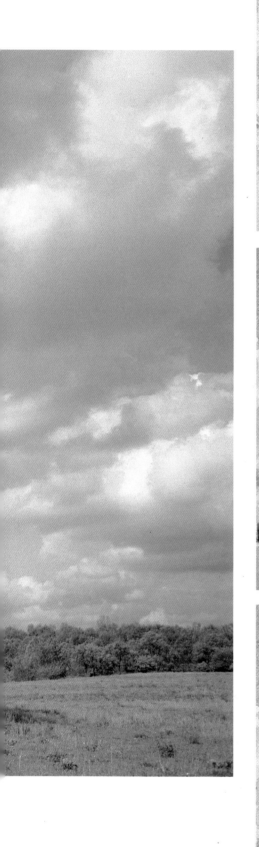

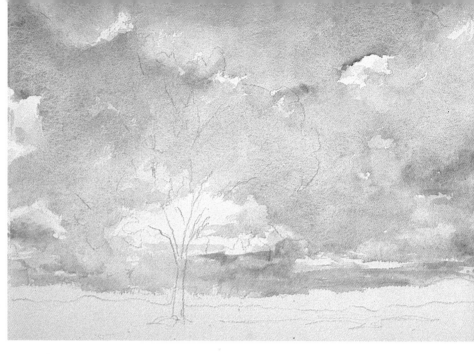

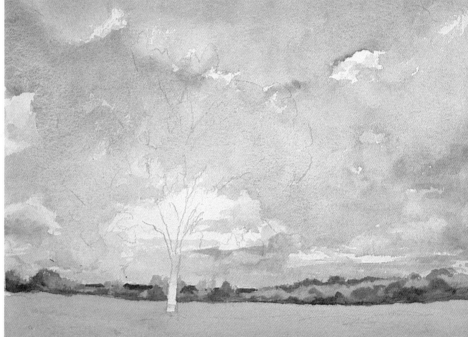

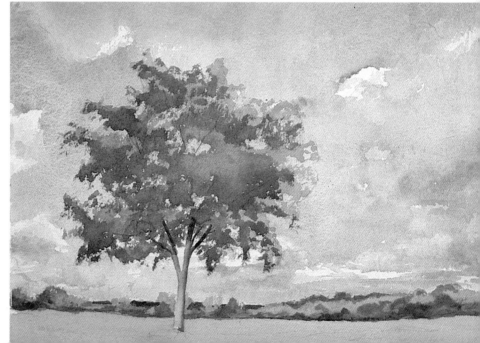

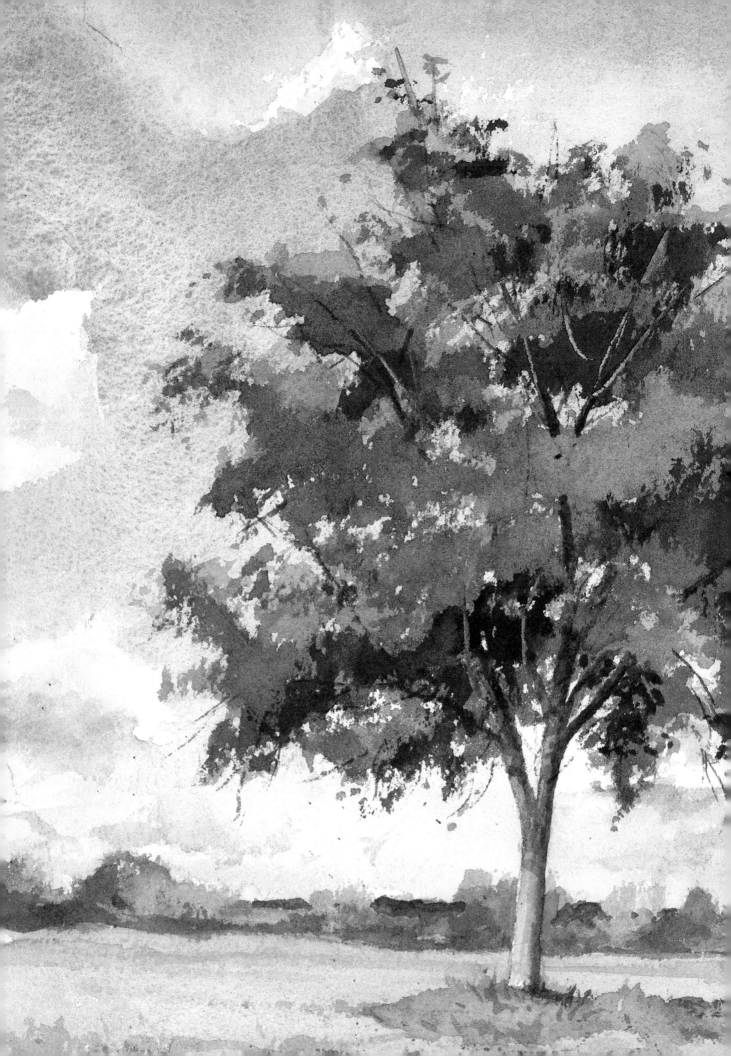

THE WATERCOLORIST'S GUIDE TO PAINTING
TREES

PAINTINGS BY FERDINAND PETRIE
Photographs by John Shaw

WATSON-GUPTILL PUBLICATIONS/NEW YORK

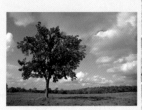

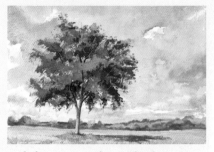

PAGES 2–3.

Bending gracefully in the wind, this elm's branches and leaves trace a delicate pattern against a brilliant spring sky.

This rendering of the elm tree shown in the photograph on page 1 suggests the tree's fresh foliage without paying too much attention to every leaf and branch. Before you begin to paint, analyze overall shapes and major masses of color and value. Concentrate on large areas first; you can always add more detail later.

Start by laying in the sky. Use broad strokes over most of the surface, but leave some areas white to indicate clouds. Next, start developing the tree trunk. When the paper dries, work in the shadow along the sides of the trunk and add the larger branches. Put down all the light leaf masses, then, while they are still wet, start working on the darker areas.

To pull the painting together, try using stippling. Moisten a stiff brush with rich, deep green paint, then tap the brush against the paper to indicate groups of leaves.

Finally, to keep the surface alive, try spattering pigment on the leaves. These irregular touches break up any area that still seems flat, and, at the same time, add some nice uneven interest to the painting.

PAGES 4–7.

On a late afternoon in May, an elm with fresh spring-green leaves stands out against a cloud-filled eastern sky.

At first glance, this subject seems easy to capture in watercolor—the light is good, the colors clear, and the composition simple. But when you begin to paint, a problem emerges: The sky is dramatic enough to make the elm seem incidental. To control the sky, paint it in one quick step. If your first attempt fails, start over: the key to handling a strong sky like this is to keep it fresh and unstudied.

Before you begin painting the tree, analyze its silhouette. In your sketch, show the mass formed by the dome of the tree and the areas where the leaves haven't yet filled in. Then, working rapidly on a wet ground, put down your pigments.

After the sky dries, use a wet brush to soften some of the clouds.

Next mask out the tree trunk and begin to develop the foreground. First establish the mass of trees along the horizon, then apply a pale wash to the immediate foreground.

As you begin working on the tree, emphasize its overall shape, not its details. Use a variety of greens mixed from your blue and yellow pigments. You'll come up with a number of related tones and you'll be able to control the colors' warmth more easily than if you used a miscellany of green pigments from tubes.

Add the final touches of detail: the dark hues on the side of the trunk, the touches of deeper green amid the leaves, and, on the ground, the shadow cast by the tree. Finally, the immediate foreground comes alive as you apply light touches of dark green to the lower left side.

First published 1984 in New York by Watson-Guptill Publications, a division of Billboard Publications, Inc., 1515 Broadway, New York, N.Y. 10036

Library of Congress Cataloging in Publication Data
Main entry under title: The Watercolorist's guide to painting trees.
Includes index.
1. Trees in art. 2. Water-color painting—Technique. I. Petrie, Ferdinand, 1925-
II. Shaw, John, 1944-
ND2244.W37 1984 751.42′2434 84-2288
ISBN 0-8230-2159-9

Distributed in the United Kingdom by Phaidon Press Ltd., Littlegate House, St. Ebbe's St., Oxford

Manufactured in Japan

First Printing, 1984
1 2 3 4 5 6 7 8 9 10/89 88 87 86 85 84

Contents

Introduction

Why should there be a whole book devoted to painting trees in watercolor? Aren't trees just a small part of the landscape, one element among many, many others? The answer to this second question is an emphatic and resounding *no*.

Unless you just paint seascapes or the bleakest desert scenes, the chances are that your landscapes rely on trees for their focus and excitement. In fact, one of the most challenging parts of landscape painting is capturing the feel of different kinds of trees in different seasons of the year.

What artist doesn't want to convey the rush of brilliant color formed by masses of autumn leaves? Or the haunting, spidery feel of bare, scraggly branches in winter?

Most people are so overwhelmed by the complexity of a landscape that they treat all its elements—the sky, the ground, and the foliage—equally. As a result, their paintings often lack emphasis and power.

To overcome this obstacle, we present concrete problems the painter encounters when working with trees, and then offer practical solutions—solutions that work—to the most common situations confronting the watercolorist.

Here you'll find how to capture the rough feel of pine needles, how to most effectively indicate masses of spring leaves silhouetted against a bright blue sky, how to evoke the sensation a dense fog creates as it creeps in on a forest, and much, much more. Practical pointers demystify the process of painting trees and make it easy for anyone to paint effective, vigorous landscapes.

But that is only part of what this book offers.

As we move from the panoramic to the minute, an exciting new dimension in watercolor painting unfolds. Many of these fifty lessons explore the countless details that abound in the outdoors, most of which painting guides usually overlook—colorful leaf litter lying on the forest floor, a jumble of pine needles supporting a delicate spider's web, or a close-up of pale apple blossoms resting against a vibrant green backdrop.

Using the examples we provide as a touchstone, you can learn how to approach trees and the world around them in a new and fascinating way.

WHO THIS BOOK IS FOR

This book is aimed at the intermediate watercolorist, but its clear, problem-solving approach makes it accessible to the beginner as well. So, if you are just starting to work with watercolor, get familiar with the rudiments of the art. Spend a little time learning the vocabulary of the craft, and, more important, how to handle a brush and mix a wash. Then start to paint.

Whether you're a beginner or an experienced painter, this book does much more than simply teach you "how to" paint trees. Of course, technique is an essential part of the watercolor painter's craft, but the most important part of painting is thinking through the problems involved and working out their solutions. Professional artists seem to do this effortlessly, but it takes experience to know where and how to begin.

It is in this area that this book will save you time and disappointment. As you read through the lessons, and try your hand at the points they cover, you'll begin to understand how to analyze what you see and how to approach your subjects.

HOW THIS BOOK IS ORGANIZED

This book contains fifty lessons, each focusing on a problem that you are likely to encounter when you paint trees. First we analyze the problem, then outline a working solution.

Of course, most situations involve more than just one problem, and you'll discover the profusion of considerations that come into play as you paint. You'll learn how the painting process works and ways in which to deal with the myriad decisions you make whenever you approach a new subject.

In all the lessons, we discuss each step involved in painting the subject, and explain what to do and how to do it. In twenty of the lessons, each step is photographed so you can see how the paintings actually evolve.

Throughout the book you will find assignments designed to help you apply what you have learned to new situations. Each assignment concentrates on one point raised in a lesson.

The lessons and assignments can be done in any order you like. To understand the assignments fully, however, study the corresponding lessons before you tackle them.

THE PHOTOGRAPHS

Every lesson includes the color photograph that the artist worked from as he executed his paintings. These photographs give you an advantage that you don't usually have—you can actually see how the artist interpreted his subject matter.

More than that, these spectacular photographs can suggest new ways in which to compose your paintings.

Before you begin each lesson, take a minute to study the subject. Examine the angle the photographer used, the distance from which he shot the picture, and the lighting conditions. Then, when you are working out your own compositions, apply what you've learned. You'll find that your paintings become much more interesting and dynamic.

WHY DRAWING MATTERS

You don't have to be an accomplished draftsman to work in watercolor, but it helps if you've mastered the basics of good, clear drawing. Executing a preliminary sketch gives you a chance to think through your composition and to analyze which elements are most important.

Every lesson begins with a preliminary sketch. As you'll discover when you begin working through the lessons, most of the drawings are cursory and simply establish the boundaries between the foreground, middle ground, and background.

Sometimes, however, we'll suggest a more detailed drawing, usually when the subject is intricate or when it's necessary to mask out a well-defined area. Don't go overboard and load your drawings with details; just indicate the basic lines of your composition.

TRANSPARENT WATERCOLOR AND GOUACHE

When most people think of watercolor, they just consider the transparent kind. But gouache is watercolor, too—opaque watercolor.

Because gouache is opaque, it can be applied on top of transparent watercolor, even when it is much lighter than the paint it is covering. For example, with gouache you can add bright yellow flowers to a dark green watercolor wash and the yellow flowers will look crisp and bright.

Some watercolor purists object to gouache—they say that it is unfair to rely on something that isn't transparent. But transparency and opacity are not the issues here—painting effective pictures is what counts.

In many of these lessons you'll encounter gouache. Each time it's used, we explain why it helps solve a particular problem.

If you have never worked with gouache before, give it a try. You will find that it handles much like transparent watercolor, and that the two media work together beautifully.

SELECTING COLORS

The following sixteen colors are used throughout this book, yet fewer than six are used in most paintings:

Ultramarine
Cerulean blue
Mauve
Alizarin crimson
Cadmium red
Cadmium yellow
Lemon yellow
New gamboge
Yellow ocher
Cadmium orange
Hooker's green
Olive green
Sepia
Burnt sienna
Payne's gray
Davy's gray.

Using these sixteen basic tube colors, you'll find that you can mix an amazing range of hues.

Since color perception varies greatly from individual to individual, don't feel bound to stick with the colors listed in the lessons. In the cases where specific ones are indicated, they are offered as suggestions, not absolutes.

CHOOSING YOUR BRUSHES

You will need both round and flat brushes. The round ones are the most important—you'll use them for the bulk of your work. Buy a large round brush, preferably a number 12, and several smaller ones, too. The smallest should be a number 2.

Flat brushes are useful as well and should range in width from 1″ to ¼″.

In addition, a lettering brush will be invaluable when it comes time to render thin, delicate branches.

Although many professionals prefer sable brushes, they have become so expensive that most people can't afford them today. Good synthetic brushes are available; some mimic the feel of sable and are excellent substitutes for the costly ones made from animal hair.

MISCELLANEOUS MATERIALS

Brushes are your basic tools, but in many situations you will want to branch out and explore what other equipment can offer you.

One of the most important supplies to have on hand is masking fluid, a type of rubber cement. When you want to block out part of the paper and paint that area last, apply masking solution to the area before you start to paint. Work right over the mask, then pull it up when you are ready to work on the section that you have blocked out.

You will need a good natural sponge, too, for those times when you want to moisten the paper before you begin to drop in your paints. Choose a natural sponge, not a synthetic one; it moves more lightly over the surface of the paper and doesn't abrade it the way the less expensive synthetic ones do. A sponge or paper toweling also comes in handy for blotting up excess paint.

With a razor blade, or even the back end of your brush, you can bring out brilliant highlights when paint is still wet; just scratch the razor or wood across the damp paper. These tools are especially helpful when you want to pull out thin, delicate lines that would be almost impossible to mask.

SELECTING THE RIGHT PAPER
All the paintings in this book were done on 140-pound or 300-pound cold-pressed watercolor paper. For most situations, the 140-pound paper is fine; you will want the 300-pound paper when you plan to work with a lot of water, which can make the paper buckle. Heavy paper is also good when you plan to attack the surface with sponges or razor blades, or when you know that you'll be using heavy, scrubbing brush-strokes.

The size of the paper is important. If it is too large, it will buckle unless you stretch it; if it's too small, your painting is likely to become stiff and studied. The paintings in this book were all executed on sheets 12″ by 16″ large, a good size for most painting situations.

TECHNIQUES
The paintings were done using fundamental watercolor techniques, techniques like laying in even and graded washes, working wet-in-wet and with a dry brush, stippling, spattering, and so forth.

If any of these basic procedures sound unfamiliar to you, turn to a general book on watercolor painting and become acquainted with them before you begin to work through the lessons. In the lessons, you'll discover which techniques work most effectively in different situations and why.

CHOOSING A SUBJECT
When you begin to choose your subjects, keep them simple. There's no easier way to become discouraged than to start with an overly ambitious scene. If you want to paint an overall landscape, choose one that doesn't have too much detail. Or concentrate instead on just one or two trees.

Remember, too, that you don't have to paint everything you see. Feel free to eliminate details that seem jarring.

DEVELOPING YOUR OWN STYLE
Don't feel locked into the approaches you find here. What we present are effective solutions to many common watercolor problems, but for almost every watercolor problem other solutions exist that may work better for you.

When you turn to each new lesson, look at the photograph of the subject for a few minutes and try to figure out how you would tackle it. Then read how the painting was done.

Trust your instincts. If you think a different procedure will be more effective than the one we discuss, give it a try. Through this kind of trial and error you will eventually develop the confidence you need to work boldly in that most challenging medium, watercolor.

Capturing the Feeling Created by Backlighting

PROBLEM
There's so much going on here—all the patterns of dark and light—that it's hard to simplify the scene enough to let the radiance of the field shine through.

SOLUTION
Since the brilliant yellows and yellowish-greens are so important here, work them out first. Yellow is an easy color to intensify or lighten as you develop the painting.

On a late summer afternoon, this maple is in sharp contrast to the sun-filled meadow behind it.

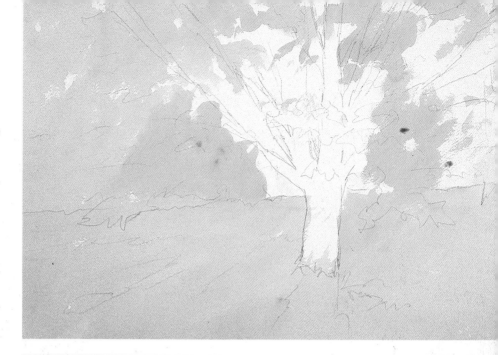

STEP ONE

In a complicated painting like this, a preliminary sketch is especially important. Establish the horizon and the shape formed by the spreading branches, and suggest the way the foreground seems to rush back to a point on the horizon behind the trunk. Begin simplifying right away: Leave the sky white. All the yellows and greens will warm it up eventually. Finally, lay in all the sunlit spaces with a strong wash of new gamboge.

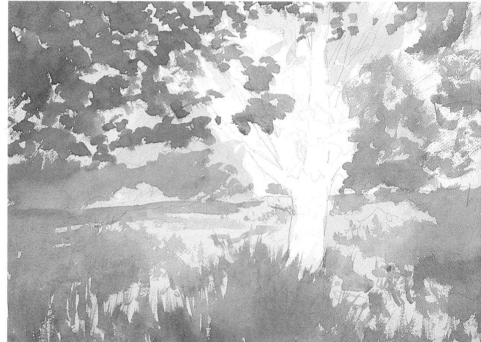

STEP TWO

Once the yellow wash has dried, it's time to start building up the greens. Mix new gamboge with ultramarine, then darken it with Payne's gray. By using varying amounts of the three pigments, you can make several harmonizing shades. Begin painting with an intermediate shade, laying down the fairly bright greens, then, using a deeper mixture, develop the moderately dark areas found mostly in the foreground.

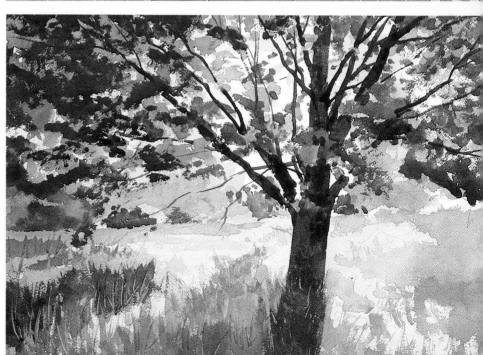

STEP THREE

When values matter as much as they do here, put in the darkest values before you've added a lot of gradations to the lighter ones. This way, you can judge how the light and intermediate values change when they're put next to the darkest ones, and then adjust them. The trunk goes down first, then the darkest masses of leaves.

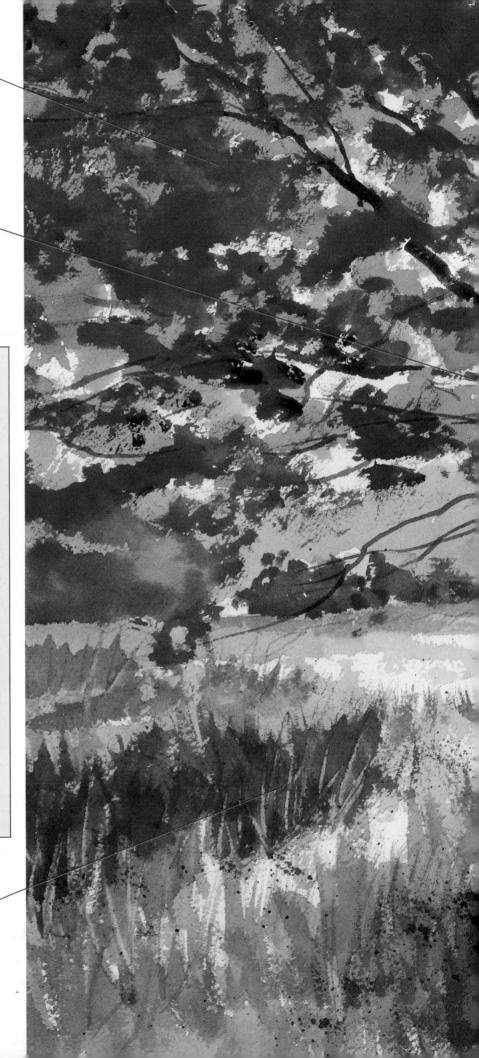

The leaf masses have a lively, irregular quality. To get this look, use a technique known as scumbling. Load your brush with lots of pigment, then drag its side over the paper.

The crisp, clean white paper gives the feel of the light sky, and immediately establishes the lightest value—important when you're working with so much bright yellow and dark green.

ASSIGNMENT

It's easy to find an appealing backlit scene—sit under any shady tree looking through its branches into the sunlight. But before you set up your paper and paints, make sure you've chosen a subject that will help you master the points we've covered here. You'll be learning how to balance extreme contrasts created by deep shadows and dazzling sunshine. Composition isn't an issue, so select a simple tree with a clean silhouette, set against a fairly uncomplicated background. Most important, the tree's crown should be fairly solid, without a lot of sky showing through its leaves and branches.

Start with the sunlit area in the background. Experiment with controlling the strong yellows, then go on and build up your greens. Minimize texture and detail. Most important, don't pay too much attention to the sky; indicate it by leaving the paper white. For now, just concentrate on your yellows and greens.

To get the kind of texture you see in the foreground, use the tip end of your brush, a palette knife, or a razor blade and pull out light areas when the paint is still slightly damp.

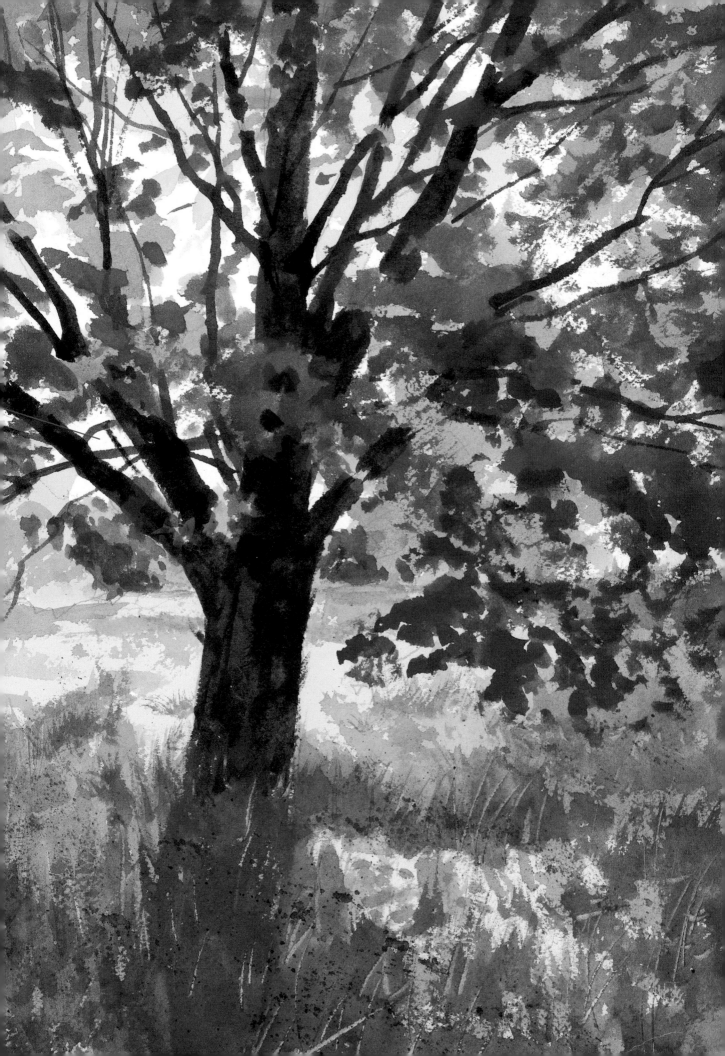

Rendering Delicate Leaves and Branches with Strong Color

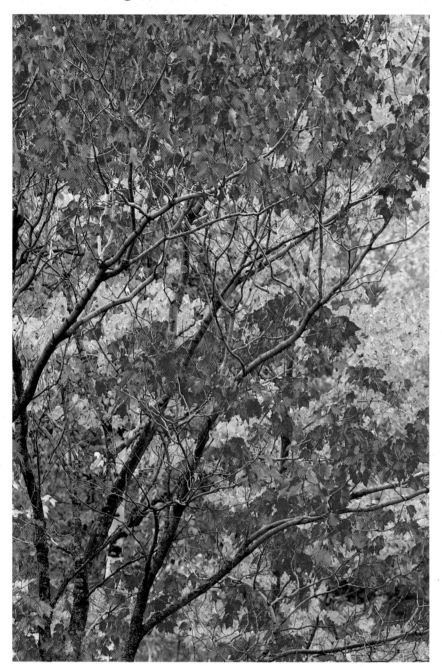

PROBLEM
The colors that dominate this autumn scene are strong, yet the trees themselves are delicate. If color overpowers the structure of the trees, the painting won't work.

SOLUTION
Analyze the masses formed by the three dominant colors and lay them down working from cool to warm tones. Don't make the masses too heavy or you'll lose the scene's delicacy.

STEP ONE
Keep the drawing simple, concentrating on the way the branches grow and the overall areas of color. Begin with the coolest color, green. It's going to tend to recede into the background when the yellows and reds are added, so put it down first. This will make it much easier to evaluate how each subsequent color affects it.

The intense red leaves of a maple in autumn dominate this vibrant, colorful tangle of branches and leaves.

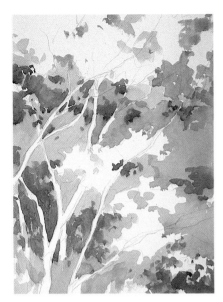

STEP TWO

After the greens are dry, begin building up the yellows. Don't just look for the obvious yellow areas; analyze how yellow permeates the entire scene. As you work, don't be afraid to put the yellow down right over the green. This freedom will keep your brushstrokes looser, and it will also add warmth to the cool green passages that you cover.

STEP THREE

Even though the red leaves in the photograph have so much texture, concentrate on flat color first. Work with a shade a little lighter than you think you'll need—it can be easy to underestimate the power of red. Before you begin texturing the leaves, put down the trunk and major branches of the tree.

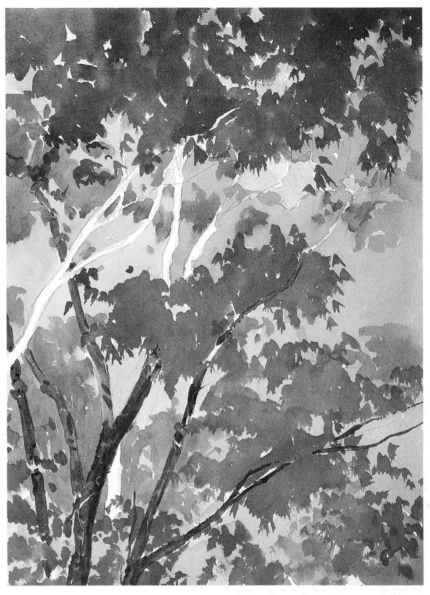

FINISHED PAINTING *(overleaf)*

When you evaluate a painting like this in its final stages, you can see how many shades of red may be necessary to suggest the delicate texture of the leaves. As you build up texture, work from light to dark. Load your brush with paint, then dab it lightly onto the paper. Don't drag it across the paper or lay on the paint too heavily. A light, irregular touch is most effective in getting across the feeling of lots of little leaves. The deepest reds that you finally add give structure to the leaf masses, and suggest the play of light and

dark on their surface. If, in the end, your painting still looks too heavy, examine the way you've treated the trunks and branches. In a tree like the maple shown here, lots of little twigs and branches are obvious in the fall. Even though they're not very prominent in a scene like this, by adding them you can enhance the feeling of how an autumn tree actually looks. To render them, use opaque paint and a drybrush technique, concentrating on those closest to you.

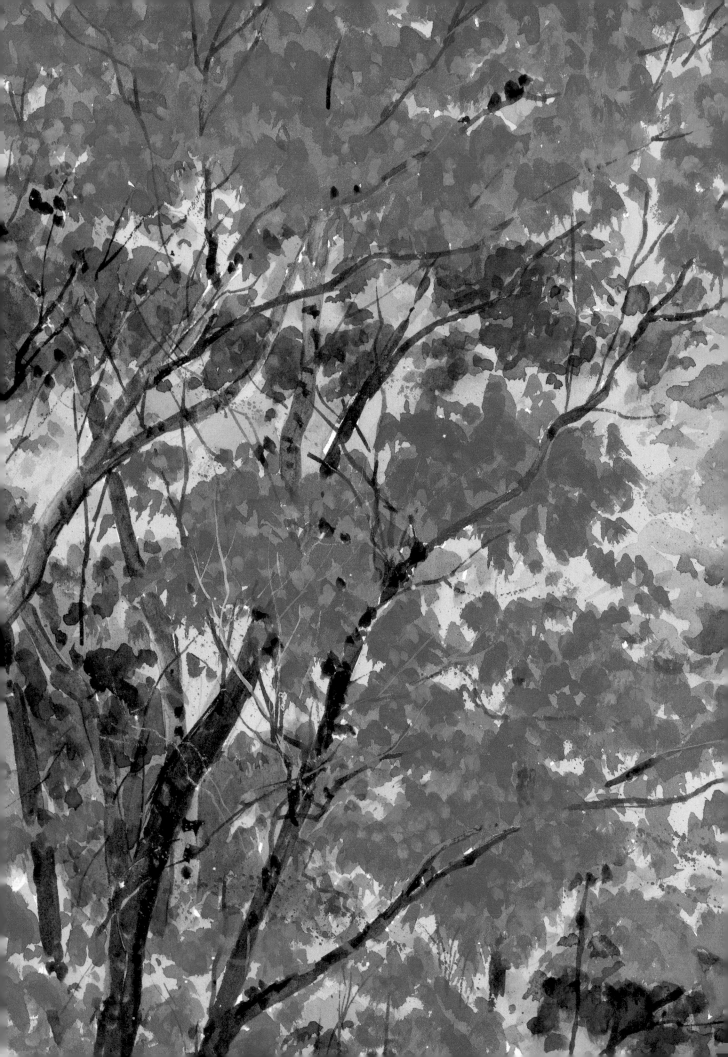

Working with Sharp Contrasts of Light, Color, and Focus

PROBLEM

Here you'll be working with two very different situations. The colorful leaves in the foreground are crisply defined and well illuminated, while the background is soft and dark.

SOLUTION

To keep the background soft, paint it first using a wet-in-wet technique. Choose a strong, heavy paper. Mask out the leaves in the foreground—you'll paint them last.

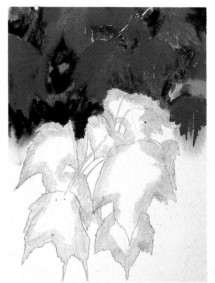

STEP ONE

You'll want a heavy paper that can stand up to all the moisture you'll be using. The 300-pound sheet used here takes a lot of water and work without buckling. Begin with a detailed drawing of the leaves in the foreground, then mask them out. When you pick up the masking solution later, you'll be able to maintain their hard edges. Wet the background, then begin to lay down the dark foliage. Use a lot of color here to keep the area from becoming dead.

Set against a soft, dark background, these maple leaves are brilliant and sharply defined.

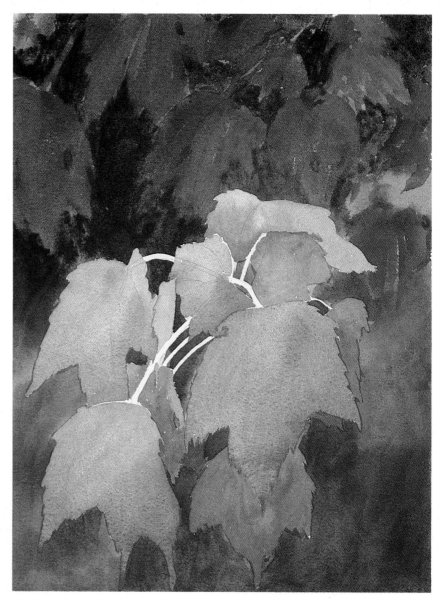

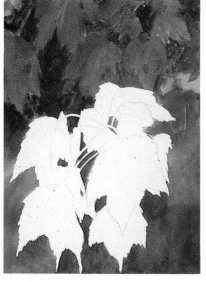

STEP TWO

Continue to develop the background. For very dark areas like those in the lower half of the painting, continue to use a broad palette. Five colors are used here: yellow ocher, sepia, mauve, olive green, and ultramarine. Because the paper's wet, you have freedom to play around, putting color down, then picking it up again with a dry brush or paper towel if it's not working out. As the paint dries, scratch out a little detail with the back of the brush.

STEP THREE

Remove the masking fluid, then paint the leaves in the foreground using graded washes of red, yellow, and orange. You want these leaves to stand out from the darker ones behind them, so work slowly, constantly gauging how the two areas work together. The foreground reds here still seem a little lackluster; they'll have to be intensified.

FINISHED PAINTING

After you've painted the leaf stems, stop and evaluate how well the painting works. Here, to brighten the leaves in the foreground, deeper concentrations of yellow and orange were put down.

But when you change one value, you change them all. Adjusting the foreground threw the background out of kilter; suddenly it seemed far too light, and the foreground too dark. A dark wash of Hooker's green, burnt sienna, and ultramarine was put down over most of the painting (but not the brightest foreground leaves), pushing the dark areas back and pulling the maple leaves out toward the front of the painting.

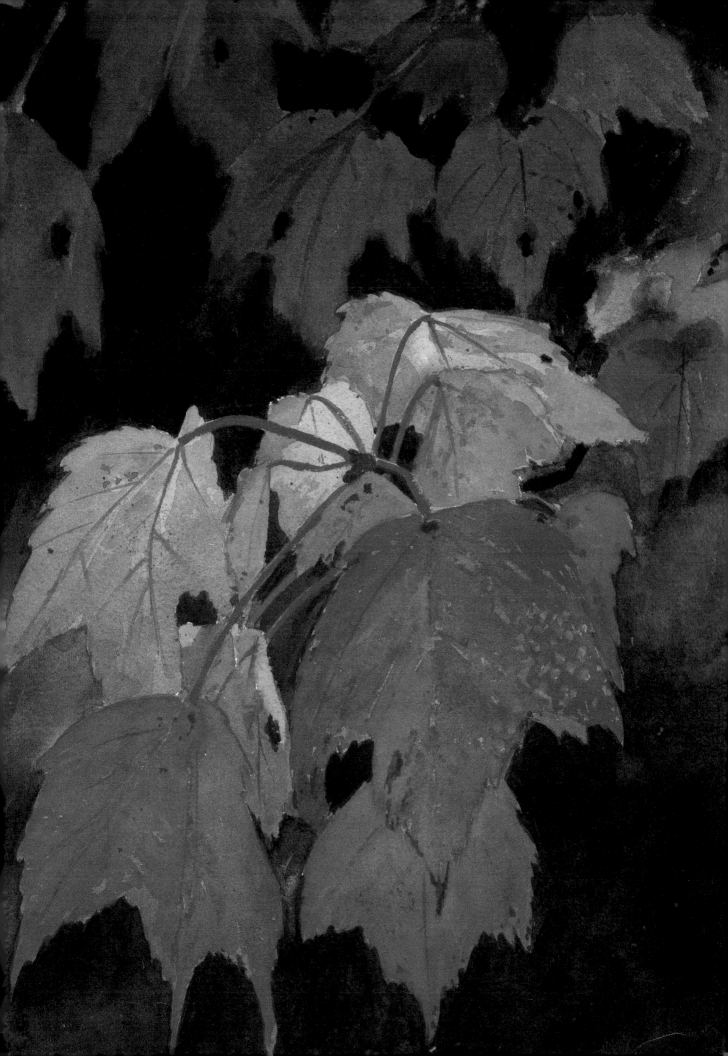

Capturing the Brilliance of Autumn Leaves

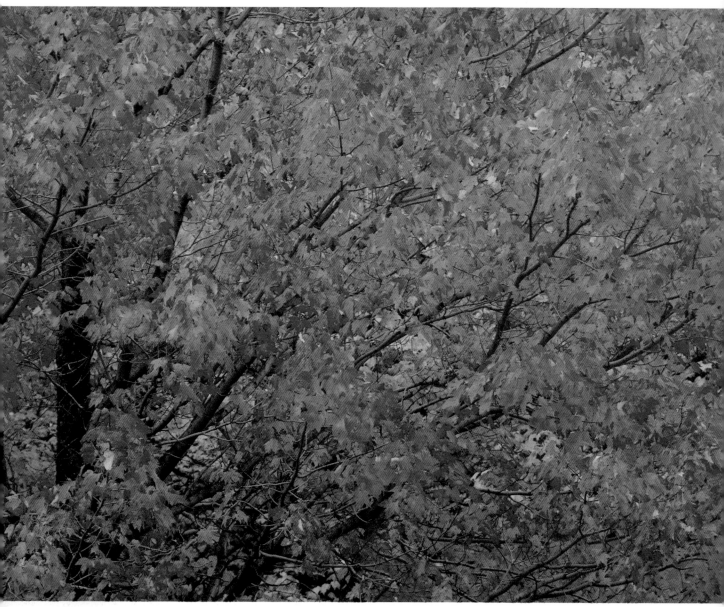

PROBLEM

The point here is to convey the exciting, vibrant feeling of fall foliage. If you get too involved with detail, you'll lose the spontaneity of the scene.

SOLUTION

Work with bold, loose strokes, concentrating on the slight variations in color that occur. Simplify, and try to pick out whatever pattern there is.

Glorious masses of richly colored maple leaves blend together in fall.

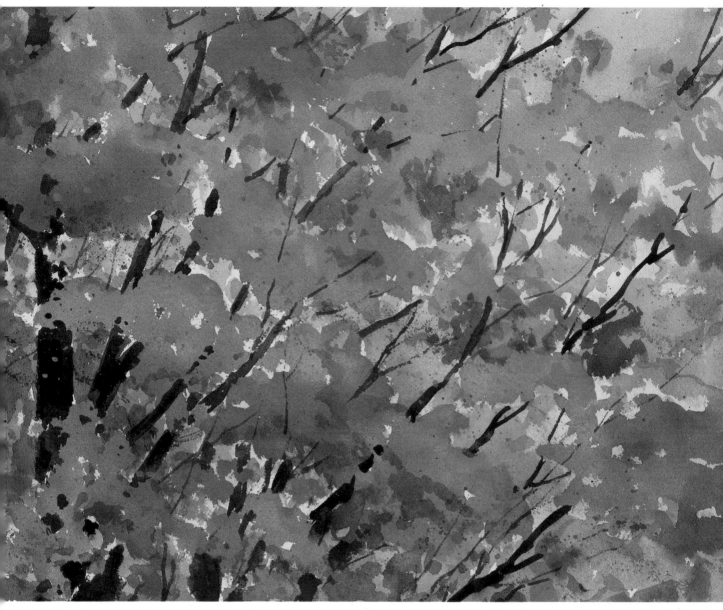

□Usually the easiest watercolor approach involves working from light to dark, but there are exceptions. Here, for example, almost all of the colors have about the same value; the pattern the leaves form is created by color, not by darks and lights, so an alternate way of working will be most effective.

Begin by following the rhythm created by the strongest color, red. Use a big, round brush to help keep your strokes strong and loose. Be sure to leave some holes in the leaf masses to sug-

gest their lacy quality, and keep their edges lively. After you've tackled the patterns that the reds form and while your paint is still wet, drop some darker pigment onto the red areas. Blend in the darker paint, again using fluid strokes.

When the paper has dried, it's time to add the yellows, golds, and greens. Just as before, the patches of paint should have erratic, uneven contours. While the paper is still wet, drop bits of darker paint into your washes and work them about to keep the

surface from becoming too flat.

Next, add the trunk and branches. Since they pull the scene together by getting across the tree's structure, stop and think before you begin to paint. The branches should reach outward and embrace all areas of the painting and they should connect, one to another. Vary the heaviness and the shape of your strokes, and be sure that they don't get too tight. As a final touch, spatter a small amount of paint in the areas that seem a little flat—here, the corners.

Making Sense of Distant Masses of Color

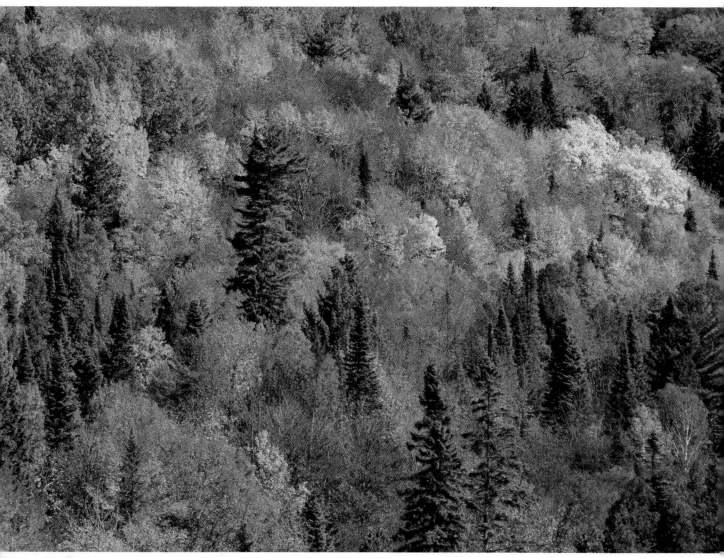

PROBLEM
The orange, red, and yellow masses may first catch the eye, but it's the deep green conifers that define the structure of this landscape.

SOLUTION
Develop the brightest areas first, paying attention to the way in which the vibrant masses blend together. Then, to punctuate the scene, add the deep greens.

For as far as the eye can see, an autumn hillside is covered with a glorious mass of brightly colored trees.

STEP ONE

In your drawing, try to map out the basic fields of color. Don't get too literal here; what you want is just a simple outline to help you keep the patterns in mind as you begin to paint. Concentrate especially on the most brilliant areas and on the outlines created by the green trees. Next, start laying down the very brightest colors, here pure lemon yellow and cadmium red.

STEP TWO

Wet the entire paper except for the sections where you've established the yellow and red. Begin to lay in various shades of yellow, orange, and red. As you work, you'll discover the close value relationships between your reds and oranges, and how they tend to blend together. Vary the strength of your washes to strengthen or weaken the values, and try to keep the painting lively. You're aiming for a dynamic surface, with lots of variation in both color and value.

STEP THREE

While the paper is drying, start adding definite shapes to the reds and oranges. If necessary, rewet some areas and then blend the colors together; this procedure is used here in the lower left corner. When the paper has dried, begin adding the dark green trees. Give their shapes some definition.

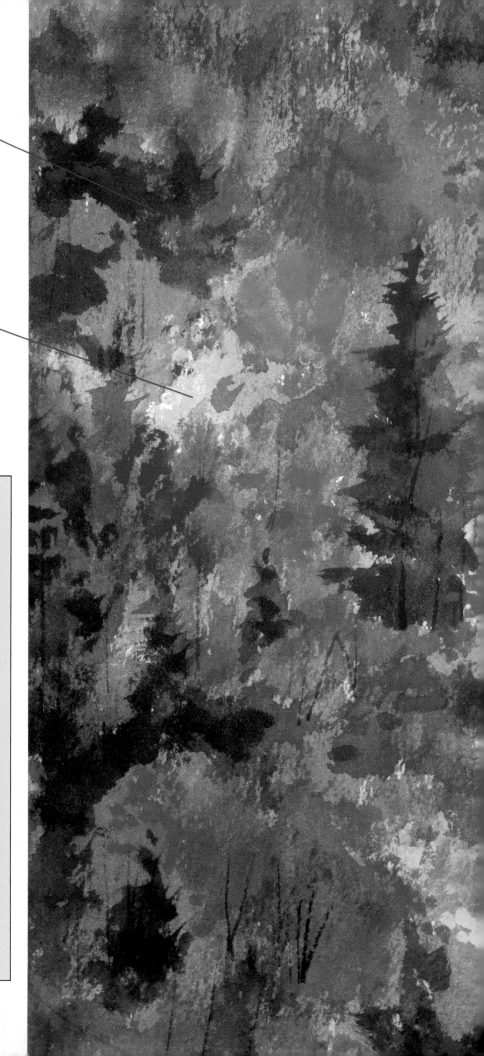

FINISHED PAINTING

The dark green conifers struck in last give the finished painting a sense of depth. They break up the indistinct orange and red masses, and get across a feeling of how the trees run up the hillside.

The yellow areas put down first have the lightest value in the painting. Just like the dark greens, though not as dramatically, they help indicate the patterns formed by the trees.

ASSIGNMENT

Anyone who paints wants to encounter and capture a dazzling autumn hillside like the one shown here. Don't wait until you find such a spectacular composition. Almost anywhere in the fall—even in a city park—you can see masses of deciduous trees in blazing color.

Here the main point is to learn to balance masses of intense color. Of course, you will also be balancing values. Instead of building up your painting from pale washes, as we've done here, work with strong color, almost straight from the tube. Don't bother to sketch the scene you've chosen; you'll be executing several quick paintings.

Work rapidly, laying down broad areas. Limit yourself to three or four colors and add the darkest value last. When you're done, analyze the pattern the colors create. Is it too evenly distributed over the paper? Or do some colors fall into clumps in one area? Keep on trying, constantly evaluating what you've done, until you are satisfied with the patterns you achieve.

Achieving a Feeling of Depth Using Light, Cool Colors

PROBLEM

These trees stretch back end-lessly to the horizon yet their leaves are all the same color. It's going to be hard to create a feeling of depth.

SOLUTION

Here you've got to edit what you see. To indicate depth, simplify the background and paint it with cool colors that suggest how the edges of objects soften as they recede.

Deep in a forest in autumn, older beech trees are surrounded by seedlings, while fallen leaves carpet the forest floor.

STEP ONE
Sketch in the trunks in the foreground, then begin to lay in the background using a wet-in-wet technique. The wash used here is made up of cool colors—mauve, ultramarine, and cerulean blue—with just a touch of warm alizarin crimson. Apply the wash using long vertical strokes to suggest the shape of the distant tree trunks, and be sure to leave some white areas between your strokes.

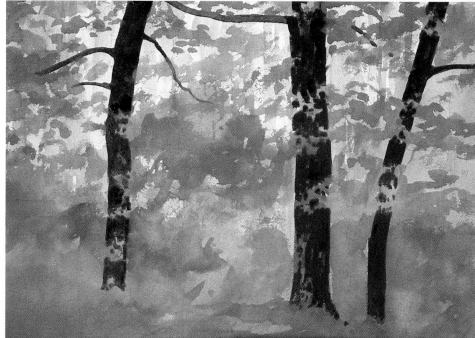

STEP TWO
Just as soon as the wash dries, put down the tree trunks in the foreground. Since their value is the darkest in the scene, having them there will make it possible to gauge the value of the leaves as you begin to paint them. Pick out the color masses formed by the leaves and start adding these broad areas.

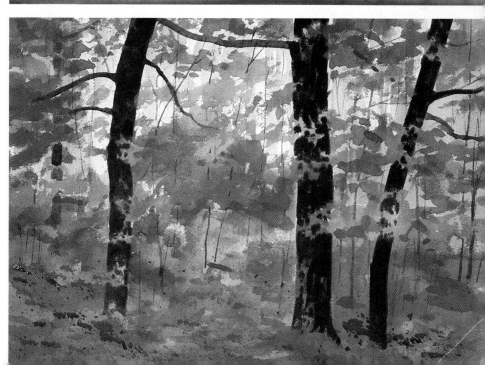

STEP THREE
Continue to develop the middle-tone values in the leaves, adding a little dark pigment—here burnt sienna—to your palette. A lot of the darkest of these middle-tone areas lie on the forest floor; using a darker wash here helps pull the ground down and differentiates it from the canopy above.

FINISHED PAINTING

Finish the painting by adding detail and texture. Use opaque gouache for the lightest leaves; you can apply it over the dark trunks and the middle-tone leaf masses. As you work, look at the pattern you're creating. Don't be too faithful to the scene in front of you; instead, keep your eye on the surface of the painting. If parts seem too static, enliven them with the gouache. To suggest the twigs and leaf litter on the forest floor, try spattering some dark wash on the bottom of the painting. During this final phase, stop constantly and evaluate what you've done; don't get so carried away with the texture that you overwork any one area.

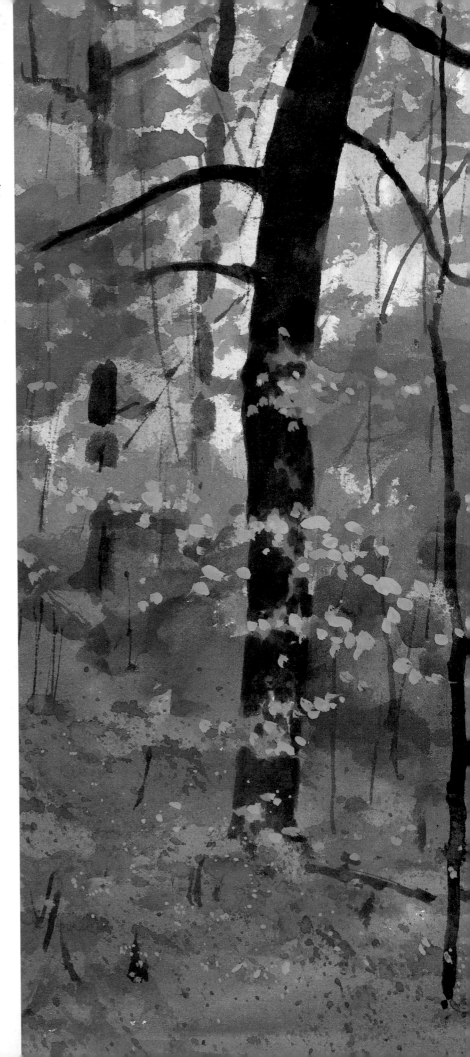

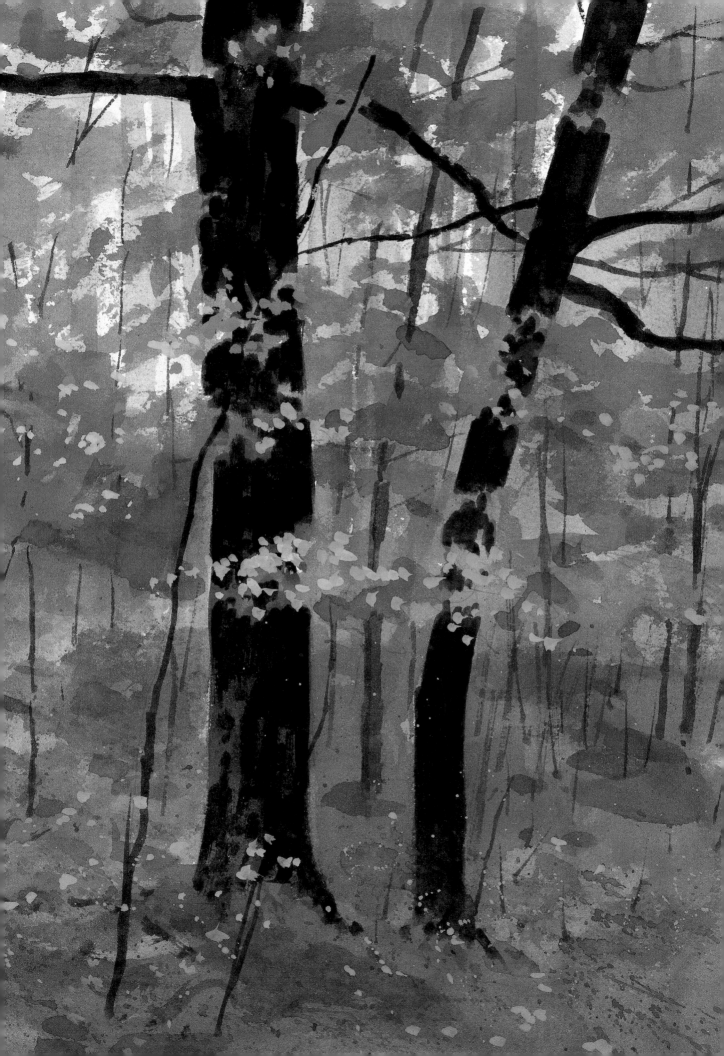

Learning How Fog Affects Color and Form

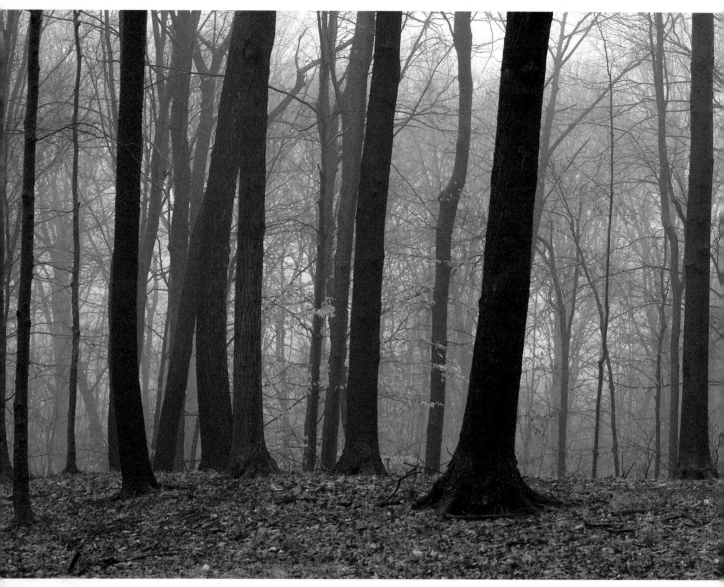

PROBLEM

Because it softens colors and the edges of objects, fog creates special problems, especially when your subject is as strong as these tree trunks.

SOLUTION

Minimize detail to suggest the effect of the moisture-laden air and use cool colors to subdue distant objects.

☐ Begin by setting down the distant background with a pale ocher wash. While your paper is still damp, use a shade just slightly darker to indicate the soft, indefinite treelike forms in the rear. Here burnt sienna and ultramarine are added to the ocher to make it increasingly duller and darker. Continue to darken your paint as you work toward the foreground; each time you do so, increase the amounts of burnt

sienna and ultramarine just a little bit. You don't want the trees to become so dark that the effect of the fog is lost. Once you've completed the tree trunks, it's time to add the few leaves that cling to the branches and those that carpet the forest floor. These leaves still have a hint of the warm color they bore in autumn, but you'll want to subdue this warmth to capture the feeling of the fog; everything appears a little lighter

On a cold winter morning,
a light fog envelops a deciduous forest.

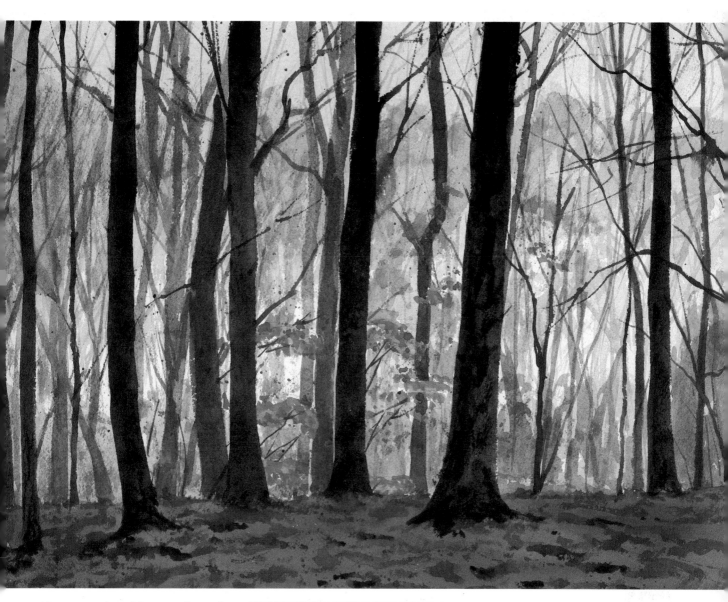

and grayer when it's seen through foggy or hazy air. To depict the soft leaves on the trees farthest back, dilute your paint slightly. Use restraint in the immediate foreground, just mixing two or three colors and applying them sparingly. If you go overboard here and make the foreground too intricate, you'll lose the misty impression you've been striving to create.

ASSIGNMENT
Experiment with muting colors so you'll be prepared when you encounter a situation like this. You'll need cadmium red, ultramarine, burnt sienna, and Payne's gray. The red is the color you're going to use in each swatch. Paint four patches of red, then, while they're wet, drop in each of the other colors, one in each swatch. Make sure that some of the red remains clear and strong. After the paper has dried, stand back and judge the effect each introduced color has created. Are some swatches more lively than others? And are some a little muddy? For your next step, put two colors into each swatch of red and proceed in the same fashion. Variations are infinite, so continue to experiment. When you begin applying what you've learned to your paintings, you'll discover which combinations work best for you.

Mastering the Color and Texture of Leaves and Acorns

PROBLEM

The acorns are clearly the focus of this scene, but you have to pay attention to the leaves as well. Their rich color and intricate patterns act as a backdrop for the acorns.

SOLUTION

Work on your base colors first, then go back and narrow in on texture and detail. Don't get caught up in any one area as you render the leaves; what makes them the backbone of this scene is their lively uniformity.

☐ A good clear drawing is important because you'll be working around the leaves and acorns. Start with the dark background, laying in ultramarine, Payne's gray, and burnt sienna. Don't just paint the obvious places; remember all the little crevices between the leaves. Next, working around the acorns, put a flat tone of yellow ocher over all the leaves. When your wash is dry, add detail to the leaves. Here two kinds of strokes are employed— soft, rounded dabs rendered with a small round brush, and light feathery strokes, added last with a dry brush.

To achieve a three-dimensional effect, the acorns are painted with a flat brush run slowly up and down each acorn. Several washes build up their rich, mellow color and the patterns on the cap of the acorn on the left. Capturing the highlights calls for white gouache. Since the acorns are so closely related in color to the leaves on which they rest, set them off by darkening the area around them.

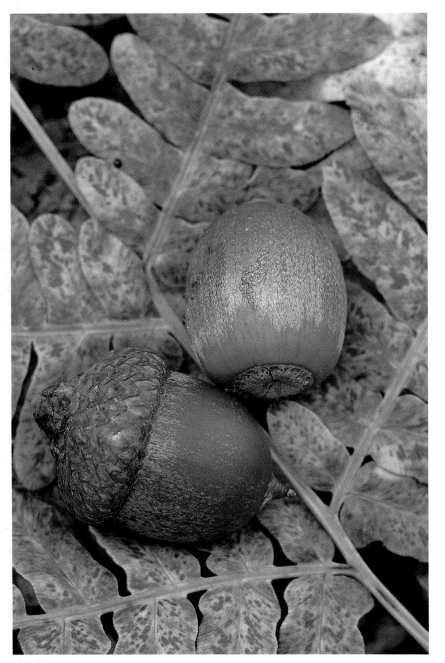

Brightly colored acorns lie cushioned on softly mottled gold and brown leaves.

ASSIGNMENT

You don't have to travel far to find appealing watercolor subjects—it just takes a little practice to learn to focus in on the simple things that are all around you. Go into a park, or even your own backyard, and look at the leaves and twigs that lie under the trees. Execute a detailed drawing of a foot or two of the ground. This sketch will train you to look at everything you see, from minute bits of leaf litter to pinecones and leaves. Next, pick just one detail from your drawing—something like the acorns here—and narrow in on it. Sketch the detail, making it much larger than lifesize, then begin your painting.

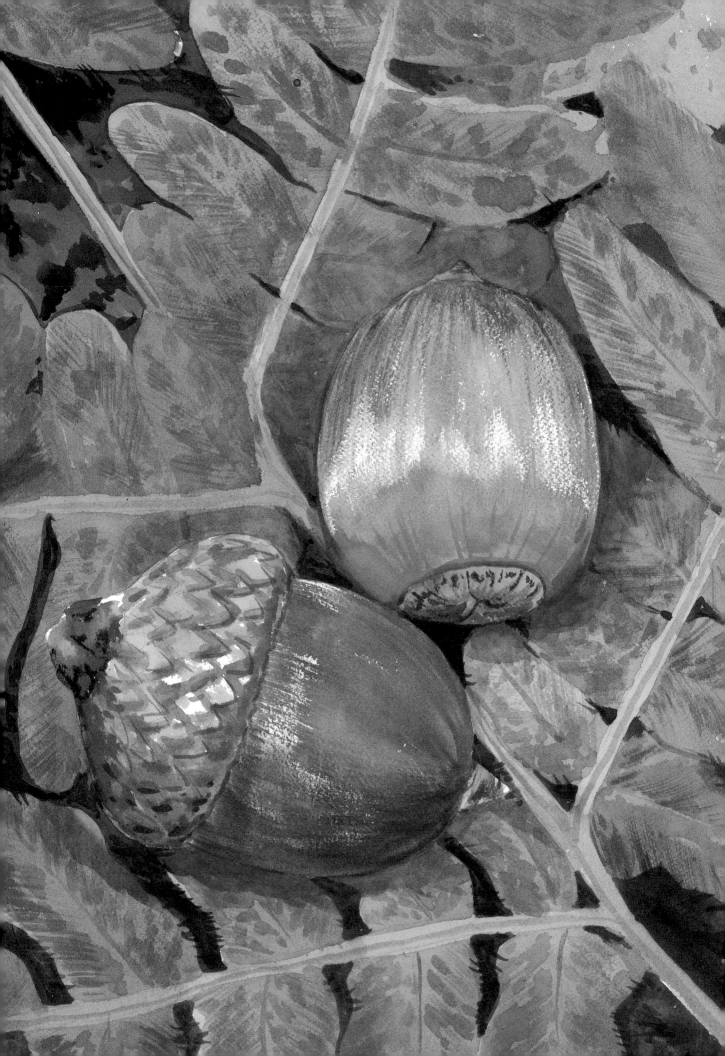

Experimenting with Fog

PROBLEM

It's easier to show how fog softens objects and makes them cooler and grayer when you're working with strong color. Here the trees themselves are mostly white and gray, and those in the foreground where the fog hasn't yet penetrated are sharply focused.

SOLUTION

Lay in a shroud of cool light gray over the background to set it off from the birches in the foreground. Play with the contrast in focus between the two areas to get across the feel of how the fog is creeping in on the scene.

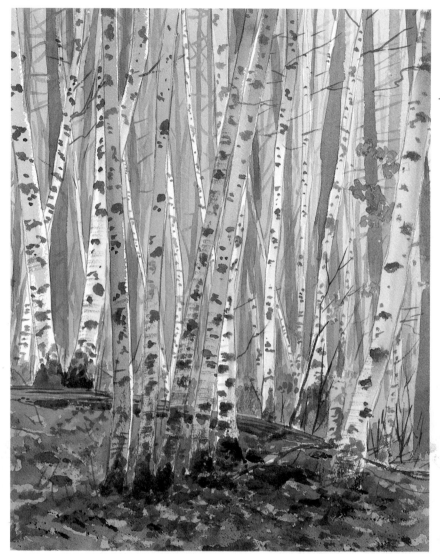

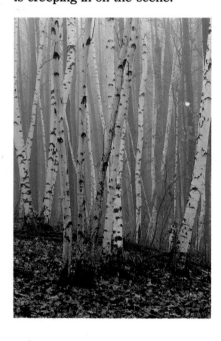

Fog softly rolls in on a stand of birches, veiling those farthest away.

□Birches are among the most appealing of trees, at least in part because of the strong abstract patterns their thin, elegant trunks form when they're massed together. Make sure your drawing captures their graceful lines before you attack the painting.

First think through the soft, muted background. For control, and to build up a strong, rhythmic pattern, stick to just three values; even the darkest will be very light. Working around the trees in the foreground, lay in the very lightest wash. Then, using the two almost imperceptibly darker washes, paint in the trees that are blanketed with fog.

You'll want warmer tones in the foreground to separate it from the area that's covered with fog, so add a little burnt sienna and yellow ocher to your gray. Carefully work out the play of light on the surface of the nearby birches. For some, let the white paper alone—it will add crisp passages to the finished painting. To depict the texture of the trunks and their fine branches, use dark gray. Finally lay in the ground with a pale ocher wash, then enliven it with rich burnt sienna and gray. Don't get carried away with detail, or you'll pull attention away from the trees.

Creating Texture with Line

PROBLEM

Two things are going on here. Although the pattern created by the fissures may seem flat and abstract, the trunk itself is three-dimensional. You have to suggest that the trunk is round, and not just get swept away by its surface detail.

SOLUTION

Forget surface detail until the very end. First work out the play of light and dark on the trunk.

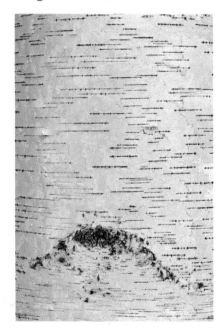

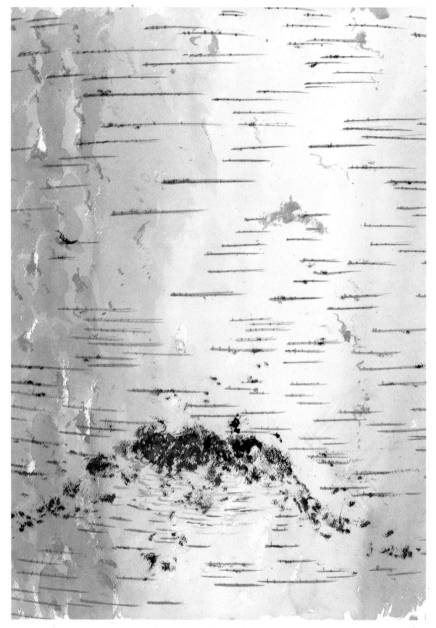

White, papery birch bark bears a simple yet intricate pattern formed by horizontal fissures and ridges.

☐ Wet the entire paper and then apply an overall wash. To achieve the light gray color seen here, use Payne's gray and just a touch of yellow ocher. Make the wash darkest toward the sides of the paper to suggest how the trunk curves back. This isn't an even wash; leave bits of paper white and establish uneven patches of shading. Now give the paper a chance to dry.

With a darker tone of gray, lay in the horizontal lines, varying their strength as you work. When they have dried, add detail. Using a dry brush and a still darker gray, dab small vertical touches of paint on the horizontal lines. This technique makes the ridges seem to be breaking open and pushing away from the trunk. Finally, add the very dark area near the bottom.

Narrowing in on Texture

PROBLEM

It's very difficult to move in this close to a subject. To suggest the bark's texture, you have to concentrate on overall pattern.

SOLUTION

To organize what could become just a maze of lines, establish the pattern formed by the bark's crevices right away. Sketch it in before you start to paint. In close-ups like this, it's easy to overwork one or two areas; the sketch will also help you keep your eye on the entire painting. You'll have more control, too, if you limit your palette to as few colors as possible. Here, just five colors were used: sepia, Payne's gray, cerulean blue, ultramarine, and yellow ocher.

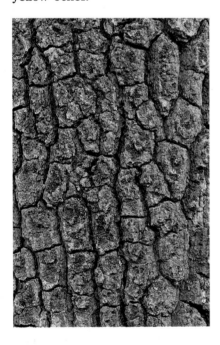

This close-up of an oak trunk reveals the abstract pattern created by the bark's cracks and crevices.

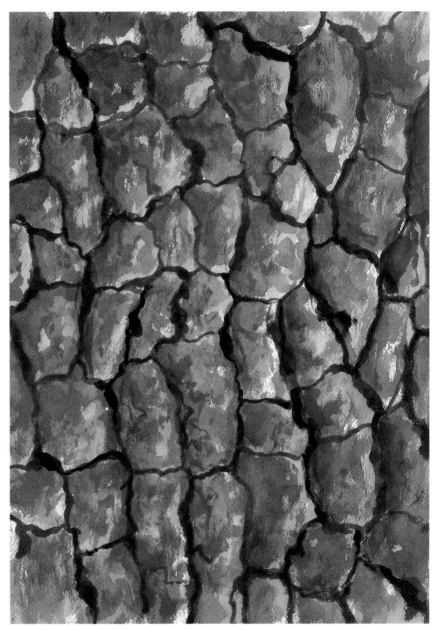

☐ Draw in the cracks, then begin to paint. Some cracks are indicated by fairly dense pigment while others are much lighter and softer. This treatment helps keep the eye from getting "stuck" in any one area and animates the entire surface of the painting. Next, lay down a grayish-brown base, leaving small sections of the paper white to suggest light reflecting off the surface of the trunk. Once the base is established, begin to develop the bark's texture by working with a dry brush to build up the feeling of roughness. If toward the end of the painting all the details seem to be fighting for attention, pull them together by applying a light wash over the entire paper. When the wash dries, strengthen the value of some of the crevices, then, once again, use a dry brush to texture areas that may still appear static.

Capturing the Feeling of Frost

PROBLEM

Fog and frost are among the hardest things to capture. Here the branches have to stand out clearly, yet they must suggest the hazy, moisture-laden air.

SOLUTION

Gouache is perfect in situations like this. Because it's opaque, you can render the frost-encased branches last, after you've worked out the delicate value relationships created by the fog.

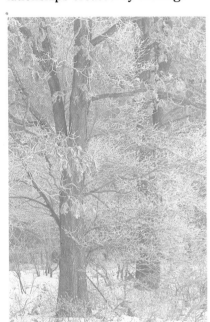

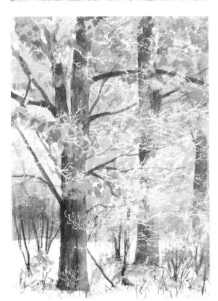

☐Establish the background using a light wash. For the ground, leave the paper white; the paper's brilliance will convey the feeling of snow more effectively than any wash can. Next put in the tree trunks, starting with the very lightest values possible. To show the masses of dead leaves clinging to the branches, introduce slightly brighter colors. Then pick up these colors in the foreground with a dry brush, pulling the two areas together. Finally, use white gouache to paint the frosty branches.

DETAIL

The fragile frost-covered branches that spill over the scene are subtly rendered with skillful brushwork. To achieve the delicate effect seen here, take a fine brush and moisten it slightly with gouache. Use wispy, discontinuous strokes and take full advantage of the uneven texture of rough watercolor paper. Learn to regulate the pressure you apply to the brush; in some places you'll want the paint just to cling to the raised areas of the paper.

Frost-filled early morning fog creates amazingly subtle variations in color and form.

Working with Closely Related Values

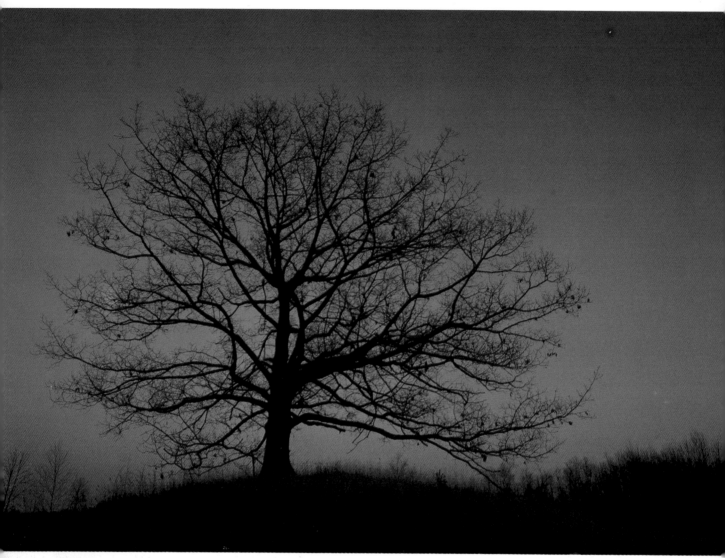

PROBLEM

The value of the darkening sky is almost exactly the same as that of the oak. Unless you're very careful, the tree and the sky are going to run together.

SOLUTION

Keep the sky lightest near the horizon and behind the tree, gradually darkening it as you move up and outward.

On a cold, crisp winter evening at dusk, this oak stands silhouetted against a rapidly deepening sky.

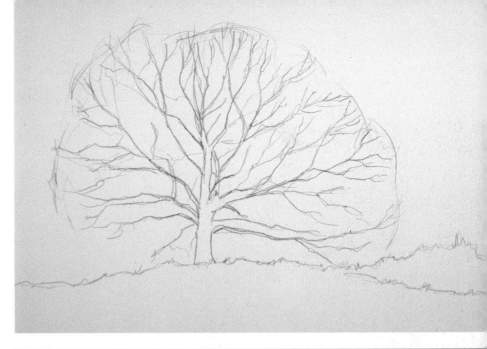

STEP ONE

Sketch the tree with heavy, dark strokes; once the wash is put down, you'll need to see your drawing through the dark paint. As you sketch, pay close attention to the tree's shape. Indicate the outline formed by the crown; this oak's shape is gently rounded and made up of strong, stout branches that almost touch the ground.

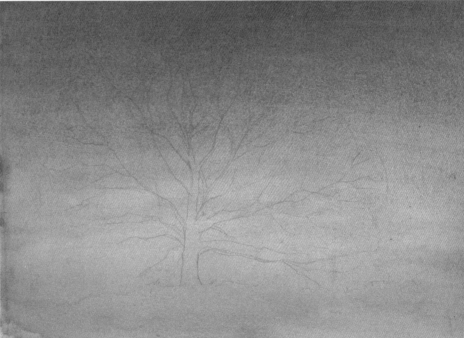

STEP TWO

When you're laying in a graded wash like this, it's easiest to work from light to dark; turn the paper upside down so the lightest area—the horizon—is on top as you work. Begin with the warmest colors—here alizarin crimson and cadmium orange. Make the wash the very lightest around the tree to create a halo effect. Here the darkest parts of the sky are rendered with cerulean blue and ultramarine.

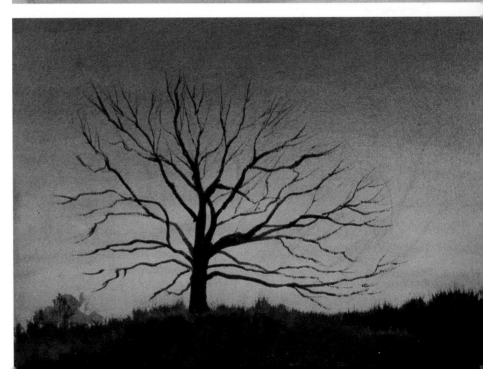

STEP THREE

As the wash dries, prepare the paint you'll use for the tree and foreground. You want the color to be dark, but not too stark. Here Payne's gray and sepia are darkened with ultramarine, a good color to try whenever you're tempted to use black. As you begin to paint, indicate the trunk and major limbs, and establish the tree's overall shape. Don't let the horizon get too fussy.

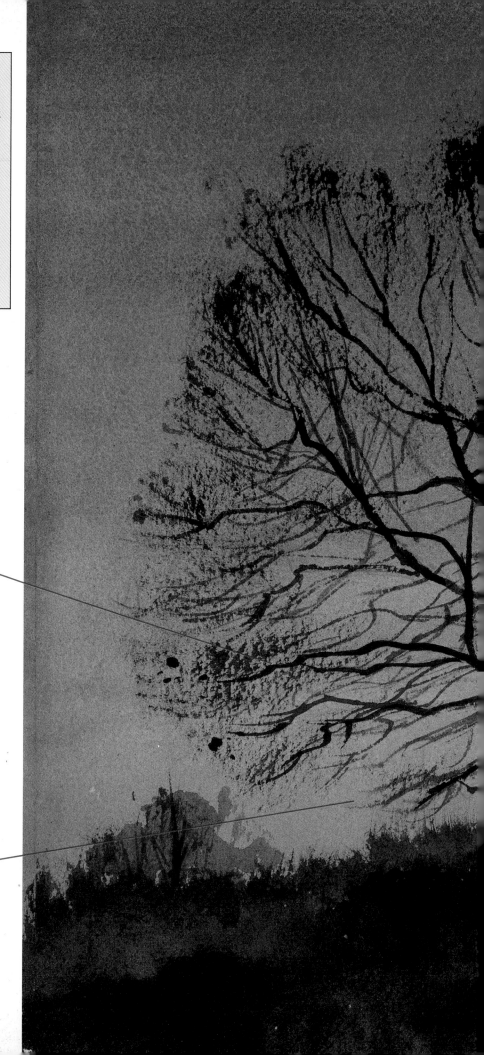

ASSIGNMENT

Choose a simple scene, one without too much detail, then do quick watercolor sketches of it at different times of day, especially at dawn and dusk. Spend just a few minutes on each painting. Use only one color; a good choice is a fairly neutral color like Payne's gray. As you work, become aware of how the light changes from minute to minute as the sun rises and sets. Once you've begun to control your lights and darks, you're ready to broaden your palette.

Use a dry brush to indicate the details. These rough strokes give the feeling of lots of little branches without pulling attention away from the tree's gnarled trunk. They're also soft enough to suggest how fading light affects detail.

In the finished painting, the tree successfully stands out against the sky, in large part because of the careful use of the graded wash. Note especially the subtle difference in value between the sky in general and the parts of it that surround the tree.

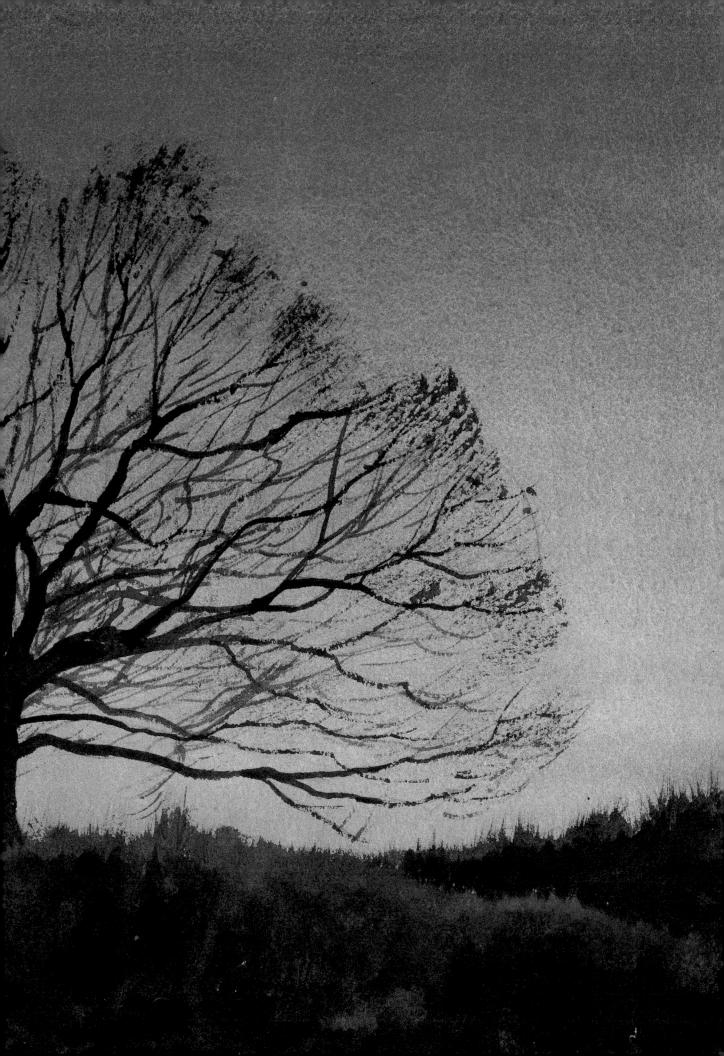

Balancing Brilliant Flowers and a Tree-filled Background

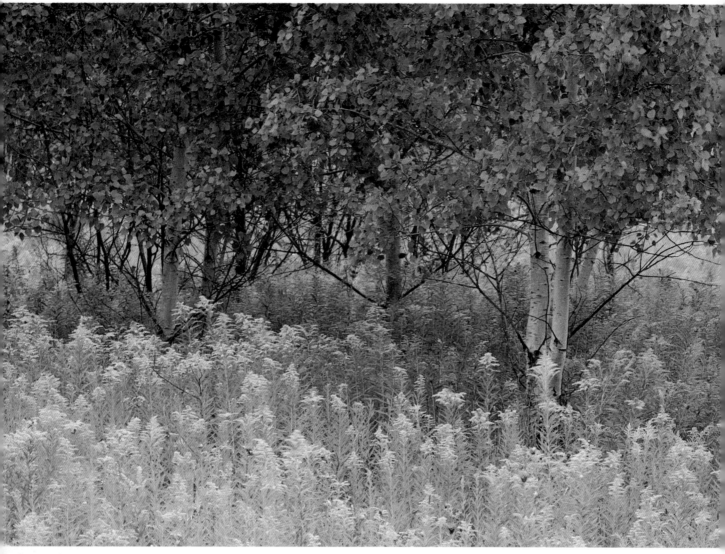

PROBLEM
When you walk into a glorious setting like this, the flowers can seem so amazingly brilliant that you may overemphasize them and fail to develop the entire scene.

SOLUTION
Paint the flowers last, so you can gauge how their color reacts with all the others you use. Mask them out before you begin to paint, and render them with gouache.

On a hot, hazy afternoon in August, this lush field of goldenrod catches the brilliant light shining through a stand of aspens.

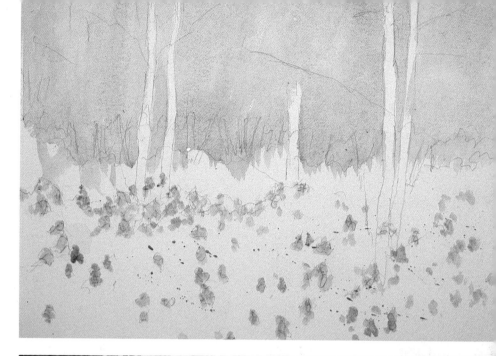

STEP ONE
Massed together, trees in full foilage seem to merge. Your preliminary drawing will keep you aware of the scene's structure. Next, lay in a pale green wash for the background. It takes experience to judge how pale the background really is; even though the paint will dry lighter than it goes down, start with a paler wash than you think you need. Paint the dark areas in the foreground.

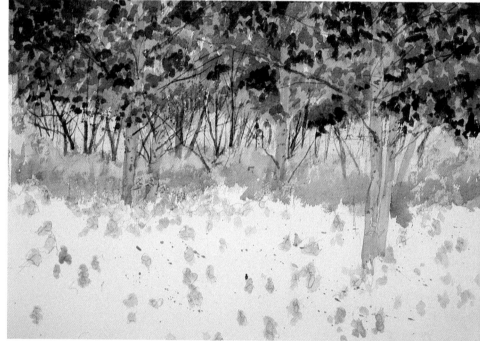

STEP TWO
Continue to build up the distant background, articulating the trunks of the small trees farthest away. At the same time, keep your eye on the middle ground. After you've set down the intermediate greens, add texture to this area while the paper is still wet. Lighten some areas by picking up paint with the tip end of the brush; darken others by spattering them with slightly darker pigment.

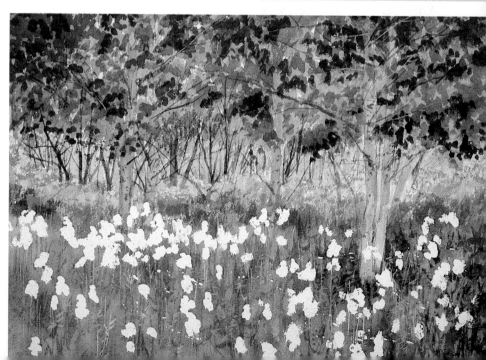

STEP THREE
Begin to work out the foreground. Keep it as lively as possible. Use a variety of greens in a variety of densities to indicate the tall stems that support the flowers. Here some are even done with pale yellow. Enrich the colors in the middle ground, too. Here yellow ocher suggests that the goldenrod extends all the way to the horizon. Next, remove the masking fluid.

FINISHED PAINTING

About all that's left to be done now are the flowers themselves. To paint them, use opaque gouache, dabbing it on quickly. After the paint dries, evaluate how successfully you've indicated space and how effectively you've developed the relationships between the goldenrod and aspen. Are the flowers in the middle ground too brilliant? If so, soften them by applying a light wash of dull green. This pushes them farther back, and makes the flowers in the foreground seem more immediate. You may want to use the same green wash to suggest the details and shadows on the flowers that are closest to you. Next, look at the trees. Do those in the foreground seem closer than those farther back? If not, add touches of strong dark green to their leaves.

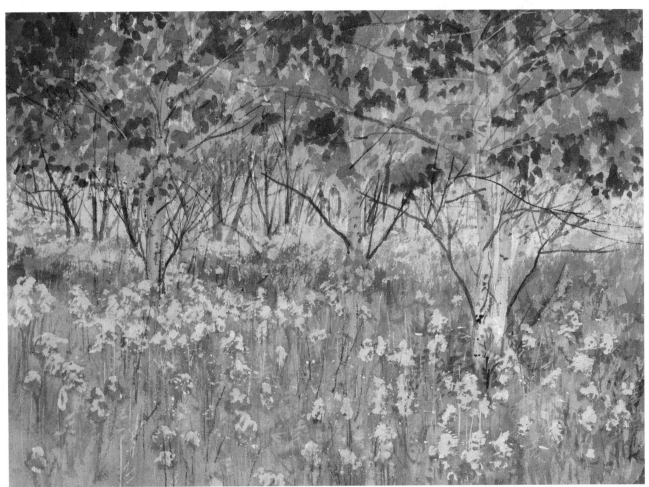

DETAIL

When you move in close and look at a detail like this you see how richly textured the finished painting is and how carefully its layers have been built up—from the initial light green wash to the final dabs of dark green. Examine the field of goldenrod and its complexity of detail. Note how the stems and flowers have been developed and how they help organize the final painting. If they were less carefully rendered, the foreground could easily become flat and uninteresting.

The middle ground has also been worked out meticulously. There's a clear sense of the hazy light shining through the aspen, then falling onto the goldenrod. The flowers and trees seem to carpet the landscape all the way to the horizon. Finally, the crisp, clean branches in the foreground contrast sharply with the paler, hazier ones farther back.

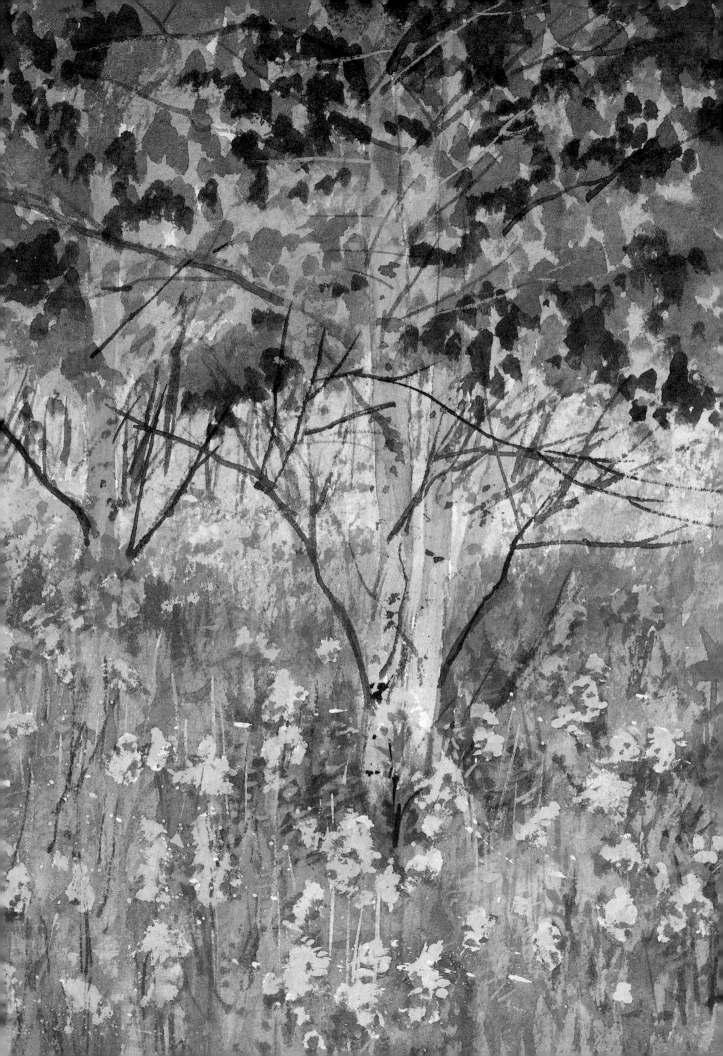

Mastering the Tiny Highlights Created by Dew

PROBLEM

This bold and elegant composition gains complexity because of the tiny beads of water on the leaves and stems. You'll want to suggest the intricacy of the leaf surfaces without sacrificing the clean lines of the composition.

SOLUTION

If the background is dark enough, the dewdrops will be thrown into sharp relief, so don't be afraid to use deep, dark paint.

☐ Execute a preliminary drawing. The leaves needn't be masked out because their shapes are fairly simple and easy to paint around. To capture the rich, mottled look of the background, work with a wet-in-wet technique. Slowly drop cerulean blue, Payne's gray, and Hooker's green light onto the paper, then blend them softly. Use really intense color here.

Wait for the background to dry, then paint the leaves with one flat wash. It's vital that you leave a white border around the leaves, so work carefully. Mix a slightly darker shade of green and then put down the areas between the veins. Next intensify the largest veins with orange-yellow paint and then indicate the shadows in the upper left corner with rich dark green.

In rendering the stems, leave the edges white to hint at the dewdrops that cling to them. For this kind of exacting work, you'll need the control that a fine brush offers. As a final touch, spatter little drops of yellow-ocher on the leaves, and add touches of brown and orange to indicate spots where the leaves are worn.

In the finished work there are only three distinct values—pure white, very dark blue, and an intermediate green. The simplicity of this scheme enhances the elegance and grace of the painting.

ASSIGNMENT

Set up a simple still life—a group of leaves or even an apple—against a piece of dark fabric that won't reflect much light; velvet and corduroy are perfect. Shine a strong light on the subject and study the highlights that form. In your painting these highlights will have the lightest value, the cloth the darkest, and the leaves or fruit an intermediate one. To show the highlights, leave the paper white.

Most people don't have much trouble with the light and intermediate values, but they're afraid to really lay on dark pigment. That's the challenge here. Concentrate on the background, making it quite a bit darker than you want it to be in the end. Remember, watercolor dries several shades lighter than it looks when it's wet.

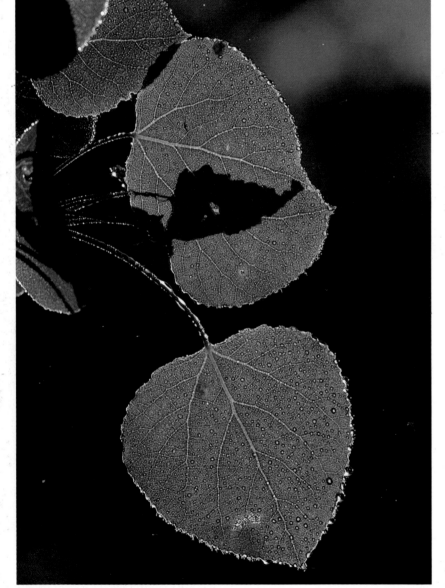

At dawn, minute drops of dew cling to bright green aspen leaves.

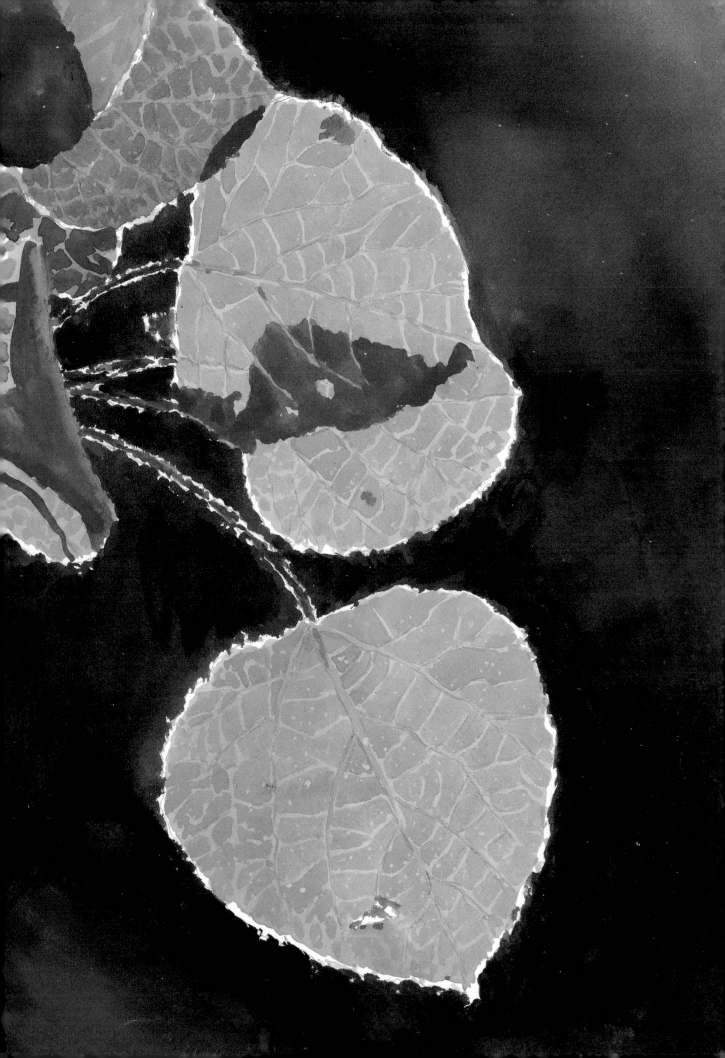

Painting a Rain-spattered Leaf

PROBLEM

Raindrops are awfully hard to paint. They're three-dimensional yet transparent. Here the situation is made even more difficult because the brightly colored leaf they hover on is resting on a dark mass of fronds.

SOLUTION

Don't worry too much about the contrast between the fronds and the aspen leaf—it's the raindrops that make this picture interesting. Concentrate on them, discovering how each seemingly transparent drop is built of shadows and highlights.

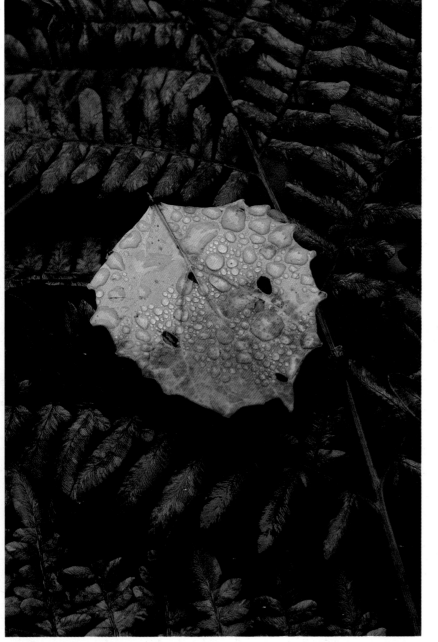

☐ Working around the aspen leaf and fronds, paint the very darkest areas in the background. When these shadowy areas are dry, lay in the fronds. First work out their basic colors, then texture them using a dry brush.

Here's where the fun starts. For the aspen leaf, try a graded wash that shifts from yellow to red. Keep the colors clear and bright to build up contrast with the dark background. When the leaf is dry, begin work on the raindrops. For each one, put down a little dab of dark color, then, using a fine brush moistened with clear water, soften the color, pulling it around the base of the drop. For interest, vary the size and the shape of the drops.

NOTE

Shadows and highlights play about on the surface of these shimmering raindrops. Notice how the color that forms the dark, shadowy area toward the bottom of each drop gradually becomes paler as it is pulled upward, then almost disappears when it reaches the top. It takes a light touch to master this technique, so be sure to do a few sample raindrops before you start to paint. After executing each drop, clean your brush before you turn to the next one, and remember to moisten the brush with clear water after you've put down the initial dab of color.

Splashed with rain, an aspen leaf lies atop a nest of rich brown fronds on the forest floor.

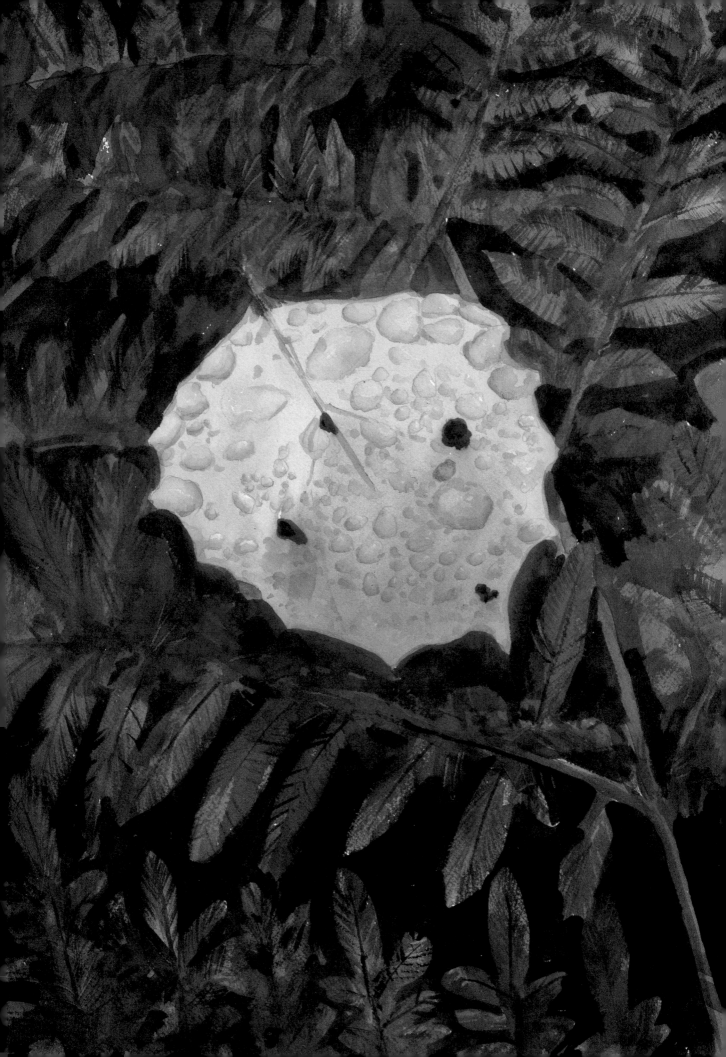

Capturing Complicated Reflections in Water

PROBLEM

The leaves are crisp and well defined, but the patterns formed by the water are difficult to read. Concentrate on them—they're going to pull the painting together.

SOLUTION

Do the most difficult area, the water, first. If you don't capture the power of the reflections and the ripples right away, start over. If you wait and execute the water last, you may have to do the entire painting again and again.

☐Since you'll be working around the leaves first, a precise drawing makes a difference. After you've completed your sketch, wet the area behind the leaves, then, going from light to dark, drop your colors onto the wet paper. As you work the colors around, keep your eye on the subtle patterns that the reflections create and on the more dynamic ones formed by the rippling water. Simplifying the ripples can help to heighten their bold feeling of movement. Here, for example, only three shades of blue can be seen. Use strong brushstrokes, but don't let the ripples overpower the soft, blurred reflections that you've already established.

After the paper is dry, lay in the leaves, beginning with flat washes, then rendering texture. This step is important. The leaves must be rich with detail or they'll look flat next to the intricate water.

NOTE

The pale pastel leaves act as a foil for the strong swirling ripples of blue that run thoughout the painting. Unlike the blue passages, which are rendered with dense pigment, the leaves are built up from delicate washes of blue, yellow, green, ocher, and brown. As a final step, their veins and textural details are added with slightly darker paint. The unexpected slash of red in the lower left corner does more than just set off the pale leaves—it also directs the eye toward the center of the painting.

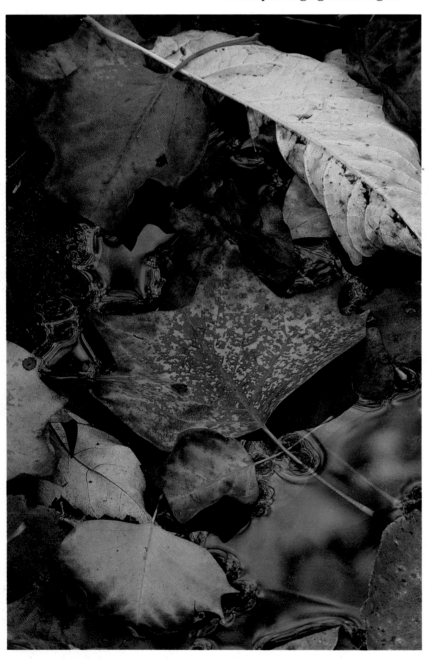

A jumble of autumn leaves lying together casts reflections in brilliant blue water.

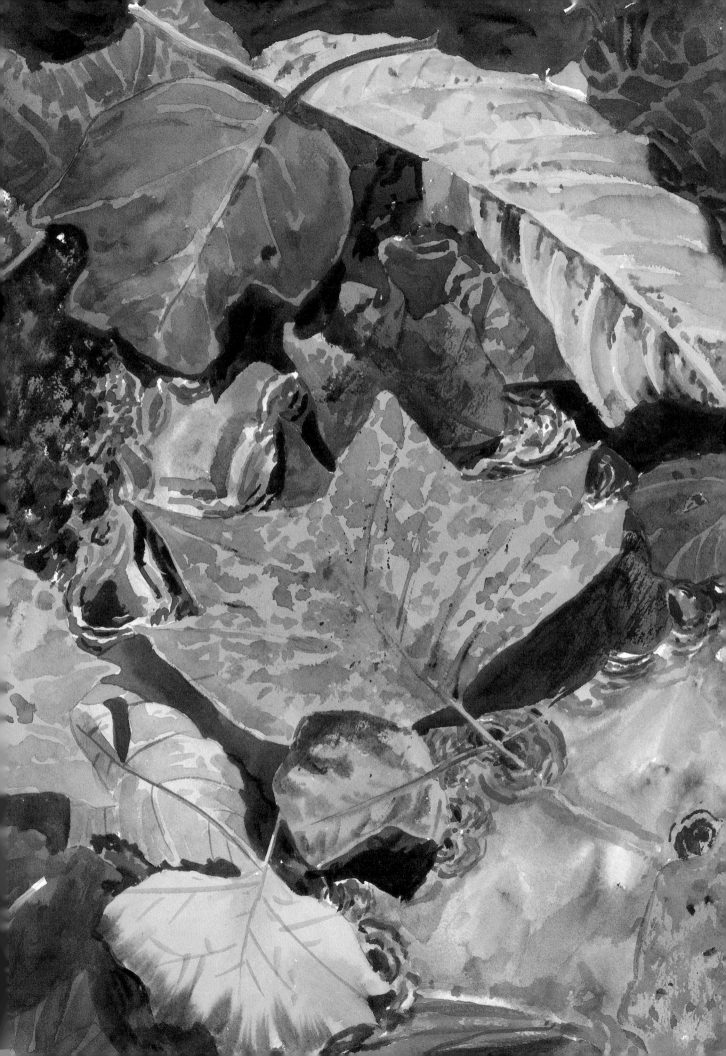

Using Monochromatic Greens to Depict Dense Foliage

PROBLEM

In the heat of late summer, trees in full foliage present an almost unrelieved screen of green. It takes some thought to decipher the structure of scenes like this one.

SOLUTION

Analyze the pattern formed by the dark, light, and intermediate greens. The light values will be the most difficult to discover; there aren't very many, and if you lose them, your painting will lack sparkle. As you search for pattern, remember why greens are so difficult. Their values are almost identical.

☐ The traditional light-to-dark approach is best for this kind of painting, so begin by covering the entire surface, except for the area where the water will go, with a very light yellow-green wash. Next—and this is the most difficult step—look for the rhythmic movement of intermediate green throughout the scene. The dark greens come next. These should

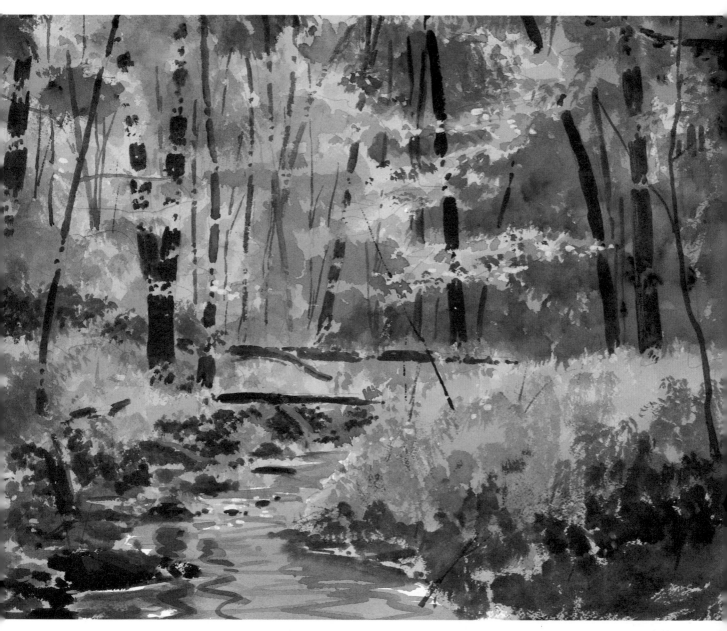

have more punch than the lighter washes, so dab paint onto the paper forcefully. Finally, add the tree trunks and the stream. Use a little imagination here; the blue passage in the stream you see in the finished painting may not be obvious in the photograph, but it adds a lively touch and breaks up the monochromatic green scheme.

ASSIGNMENT

Experiment blending greens before you tackle a difficult forest scene like this one. Start by learning how to mix warm and cool tones.

To mix a warm green, take ultramarine and new gamboge. First add just a bit of the blue to the yellow, then gradually add more and more. Each time you change the ratio of blue and yellow, paint a test swatch. To increase the warmth still further, you can add a little burnt sienna.

For your cool greens, follow the same procedure but use cerulean blue and cadmium yellow. To make the greens you mix still cooler, try adding a little Hooker's green light.

After you've completed your test swatches, compare them.

Recording the Delicate Growth Around the Base of a Tree

CYPRESS

PROBLEM

The dark tree trunks could easily overpower the greens, and if they do, you'll lose the lush, verdant quality that makes this scene so arresting.

SOLUTION

Work mostly in middle tones, using darker washes just for texture and detail. To make the green leaves that grow out of the trunks really stand out, use gouache.

☐ After your drawing, lay in all the dark areas deep in the background with a mixture of ultramarine and sepia. Next, dampen the tree trunks with clear water, then drop in yellow ocher, mauve, olive green, and burnt sienna, mixing them right on the paper.

Now turn to the ground. Start with a graded wash mixed from new gamboge and olive green. Work from the darkest areas in the background to the lighter ones up front, then add texture. Begin with small dark touches that spiral back into the painting, then load your brush with bright green paint and spatter the paint densely over the ground. Turn to the flora growing out of the trunk. Working loosely, render the leaves. Some can be soft and unfocused, but for the most part, pay attention to their shape. Finally, add just a few details— the small pink touches in the rear and the foliage springing out of the fallen trunk in the immediate foreground.

NOTE

Dense spattering is ideal for depicting masses of tiny details— here the lush, wet surface of the swamp. When you're working with this much spattering, stop from time to time and evaluate how much you've laid down. If the spatters become too dense, they'll run together and you'll lose the interesting, uneven patterns that make the surface of the painting dynamic. Try to vary the size of the spatters, too, to keep your work from becoming monotonous.

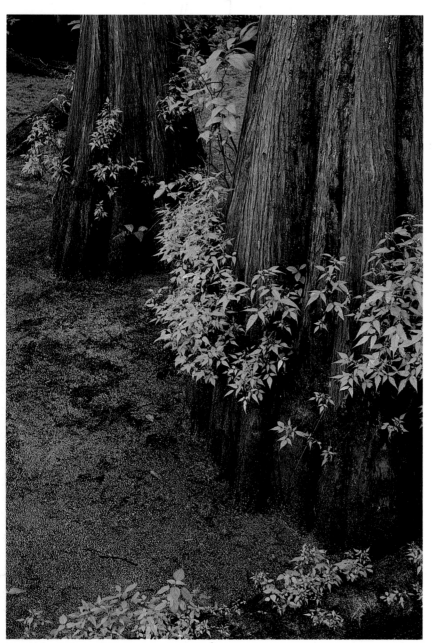

Massive cypress trunks rising from wet, swampy soil support fresh, brilliant spring growth.

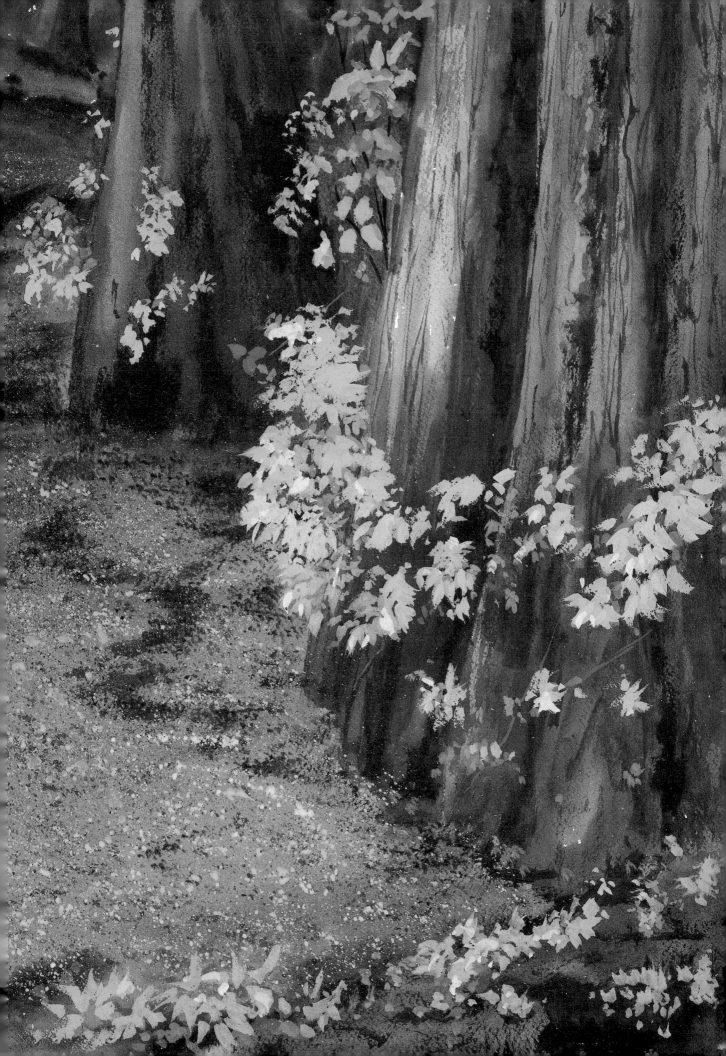

Painting Green Leaves Against a Rich Green Backdrop

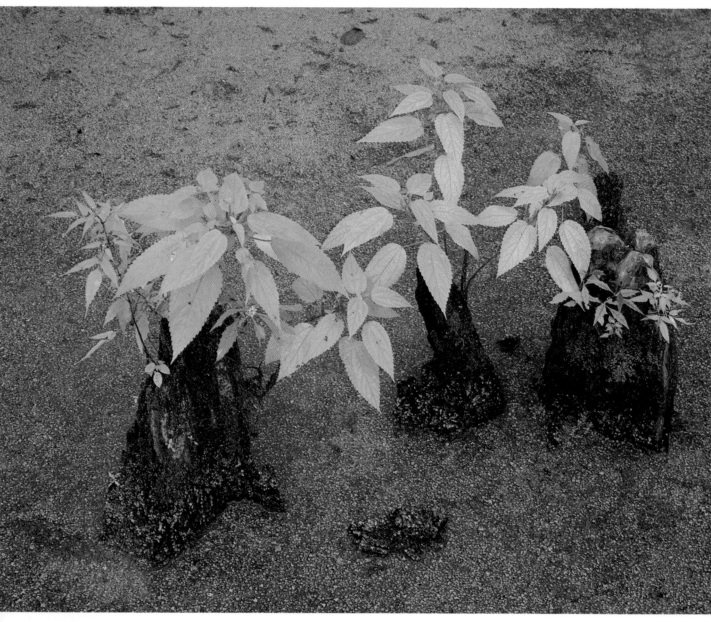

PROBLEM

Because the light is so diffuse and subdued, there is hardly any contrast here. The swampy ground is just slightly darker than the leaves.

SOLUTION

Mask out the leaves and build up the background first. When you add the leaves later, you'll be able to control their color and value and set them off from the darker ground.

☐ Execute a careful drawing of the knees, then mask out the leaves. Start the background by laying in a mottled wash—here made up of olive green, new gamboge, yellow ocher, and Payne's gray. Before you begin to add texture to the background, paint in the trunks. Next, load a brush with wet paint and spatter it over the ground.

Now it's time to remove the masking fluid and lay in the bright green leaves. To set them off

from the background, make them a little lighter and brighter than they actually are. Next, intensify some of the greens in the leaves, then paint in their veins with light, delicate strokes.

When you are almost done with your painting, gauge how successfully the ground relates to the knees. If it looks a bit too light—and it did here—wash it with Hooker's green. Then, to heighten the shadowy areas near the knees, add a light blue wash

Deep in a swamp, underwater cypress roots send oddly shaped "knees" to the surface.

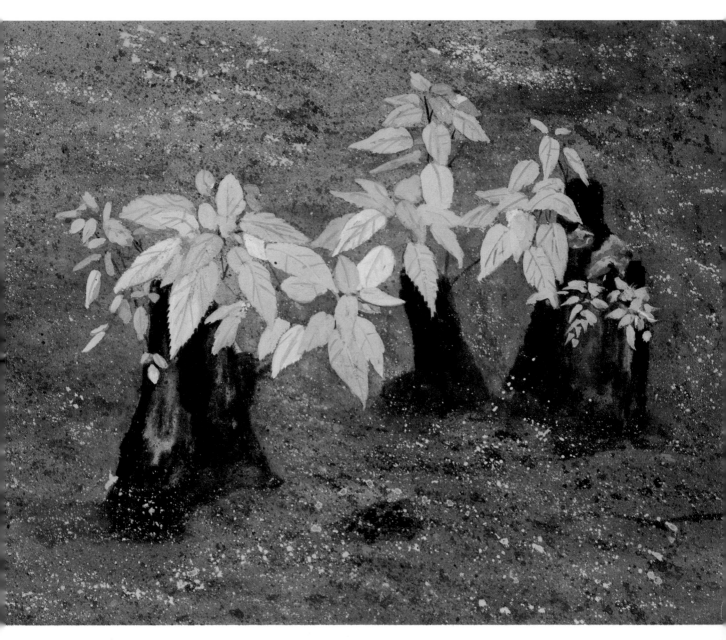

around the stumpy growths. Finally, with the same green used to intensify the color of the leaves, spatter still more paint over the background.

Note how effective the final touches are: the subtle blue wash not only picks out the shadows beneath the knees, it also helps pull the background away from the leaves and stumps; the spattering keeps the final wash from becoming too dominant.

ASSIGNMENT

Learn the different effects you can create with spattering. You'll need a large sheet of paper, small and large brushes, a toothbrush, and a tube of paint. Mix a good amount of the pigment with plenty of water—the paint should be very wet.

Take a small round brush and load it with color. Holding it over the paper, tap the brush, first with your hand, then with another brush. Experiment directing the flow of the spatters by striking the brush on one side as well as from above.

Next, try a big round brush to create larger spatters. Finally, wet a toothbrush with paint and run your thumb across the bristles to get a rich flow of tiny speckles.

Painting a Sharply Focused Subject Against a Soft Background

PROBLEM

To focus in on a subject, you have to train yourself to downplay what lies beyond it. It takes some practice to learn to subdue unimportant elements.

SOLUTION

Mask out the foreground—the real subject of your painting—and lay in a wet-in-wet background. Make sure you get a realistic feel by using related colors in both areas. Try to suggest that if the viewer merely looked up and redirected his gaze, the background would spring into focus.

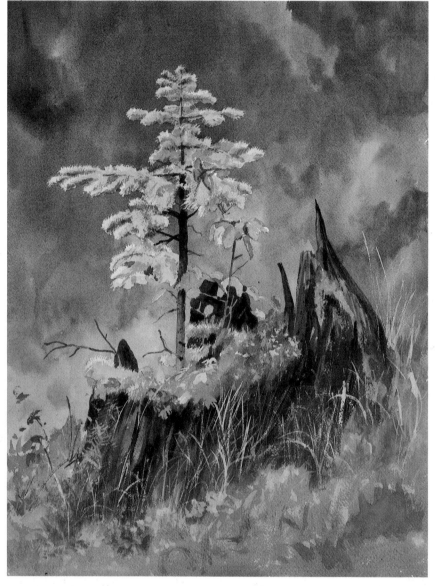

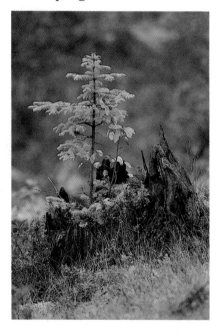

Moss, grass, and wildflowers surround a tiny spruce seedling rising out of a jagged tree stump.

☐ There's a lot of detail to the seedling and trunk, so a careful drawing is a must. Next, figure out where you'll want to maintain a sharp edge—here the stump and spruce, and the surrounding growth—then cover those sections with masking fluid. Before you begin the background, take a wet sponge and soak the paper. Now begin to drop in the paint, gently working it around to keep the surface fluid. When the paper starts to dry, add brighter colors; since the paper is damp, not wet, the paint will hold its shape yet still remain soft.

Next, peel off the masking solution and paint the seedling, trunk, moss, and flowers. Finally, to soften any harsh transitions between the foreground and background, dab a bit of gouache onto the edges of the seedling and the surrounding growth.

Establishing the Values Created by Heavy Fog

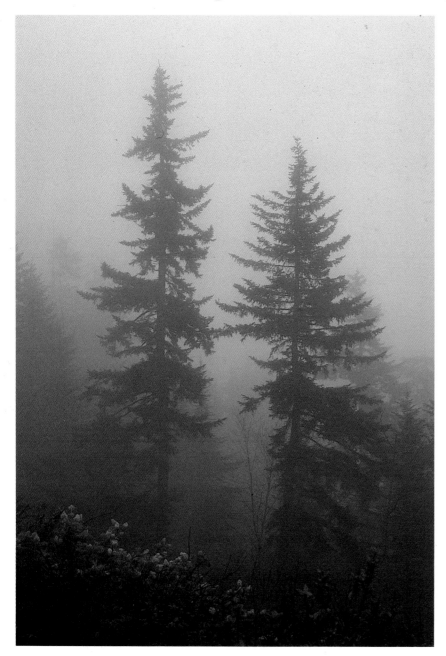

PROBLEM

Here, the scene's so foggy that all of the values run together and nothing has any definition. The soft background will be particularly difficult to paint.

SOLUTION

Even though the fog almost totally obscures the trees in the background, define their shapes using successive layers of very light wash. Make the foreground more sharply focused than it actually appears.

STEP ONE

You'll be working with a wet-in-wet technique for much of the background so use sturdy 300-pound paper. After your sketch, mask out the flowers and grass in the foreground; they'll be executed last. Next, wet the entire paper, and begin laying in a graded wash. Here it's made up of Davy's gray and yellow ocher. As you approach the foreground, intensify the wash with Payne's gray and ultramarine.

On an early spring morning, these spruce trees dominate a fog-covered mountainside.

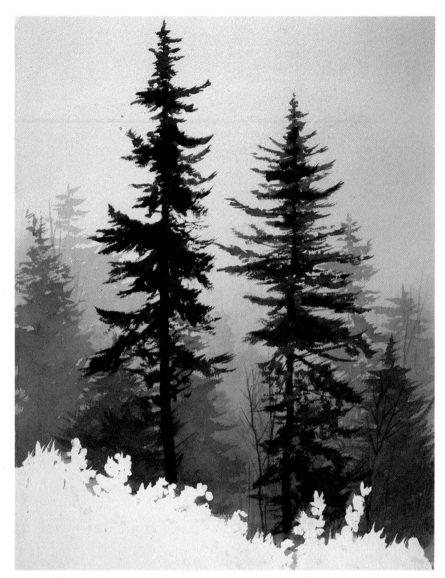

STEP TWO
After the background has dried, prepare a wash of Davey's gray, cerulean blue, and yellow ocher, then begin depicting the lightest trees in the background. Don't add texture or detail; just show their silhouettes. When they're dry, add slightly darker trees, then, when the intermediate ones have dried, add still darker trees. Each layer should be only slightly darker than the previous one.

STEP THREE
Put in the tall trees in the foreground. To make these trees really dominate the composition, paint them in a slightly darker value than what you actually see. It's essential that you capture the grace and beauty of the branches silhouetted against the lighter trees and the sky without adding very much detail. To break up the masses formed by the branches, paint the trees using two closely related shades. Using a few simple strokes, suggest the scraggly undergrowth.

As a final step, remove the mask from the foreground area and lay in a wash of green. Once this has dried, render small branches with vertical strokes, making sure to leave the white of the paper to indicate flowers.

FINISHED PAINTING
Quick, sure brushwork makes the finished painting strong and unified. In the tall, dark trees in the foreground it suggests the weight of the branches. To achieve the effect seen here, work from the trunk outward; the brush becomes drier toward the periphery of the trees, and helps convey the rough feel of their needles. The spring flowers that lie in the immediate foreground establish the season and lend a splash of color. Rendered with vertical strokes, they continue the up-and-down sensation established by the tall trees throughout the painting.

Establishing Distance Using Subtle Colors

PROBLEM

Creating a sense of distance is going to be tough here. The stands of aspen are made up of very pale colors that are almost the same in the foreground and background.

SOLUTION

Since the scene breaks into such strong horizontal zones, use vertical strokes to suggest the structure of the individual trees. At the end, details will pull out the foreground.

Stands of pine and aspen spread across a spring hillside on an overcast afternoon.

STEP ONE

There really isn't much to draw here, so just mark down the divisions between the major color zones. Prepare pale washes of yellow and mauve; with yellow pick out the central portion of the painting, and apply the mauve to indicate the far distance. Working with a broad palette—here mauve, burnt sienna, yellow ocher, alizarin crimson, new gamboge, and Hooker's green light—begin developing color masses.

STEP TWO

Add the pine trees to the central zone. Continue to use vertical strokes and minimize detail. If this section becomes too fussy, it's going to be just about impossible to get across the feeling that it's located behind the pale aspen in the foreground.

STEP THREE

With a darker green, indicate the shadows that fall on the pine trees. This is the time to begin defining the aspen trees as well. Continuing to use vertical brushstrokes, lay down intermediate washes over the paler ones you've already established.

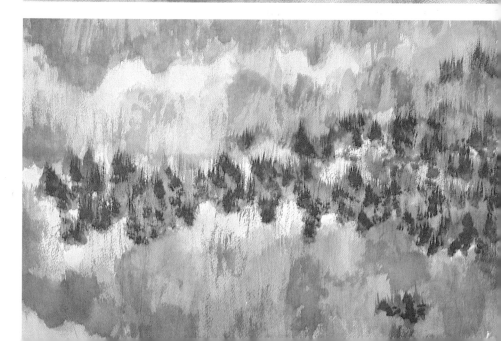

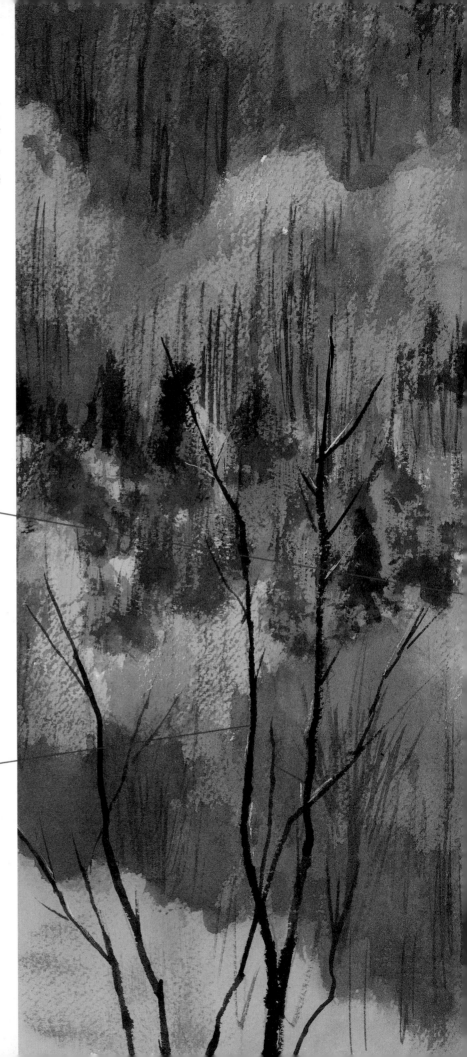

FINISHED PAINTING

To achieve the final colors, build up the horizontal color zones with washes of deeper value. Then, as a final touch, sketch in the spindly tree trunks with a lettering brush. This will give the textured effect that suggests the look of a hillside forest.

These passages of light greenish-yellow paint also help pull the foreground out toward you. Because they're more brilliant than any of the other pastel hues used, they seem closer and more immediate.

Without these scraggly branches, the entire painting would flatten out. Added at the very end, they quickly establish the foreground. Emphasizing one detail like this often sharpens all the spatial relationships that you've set up.

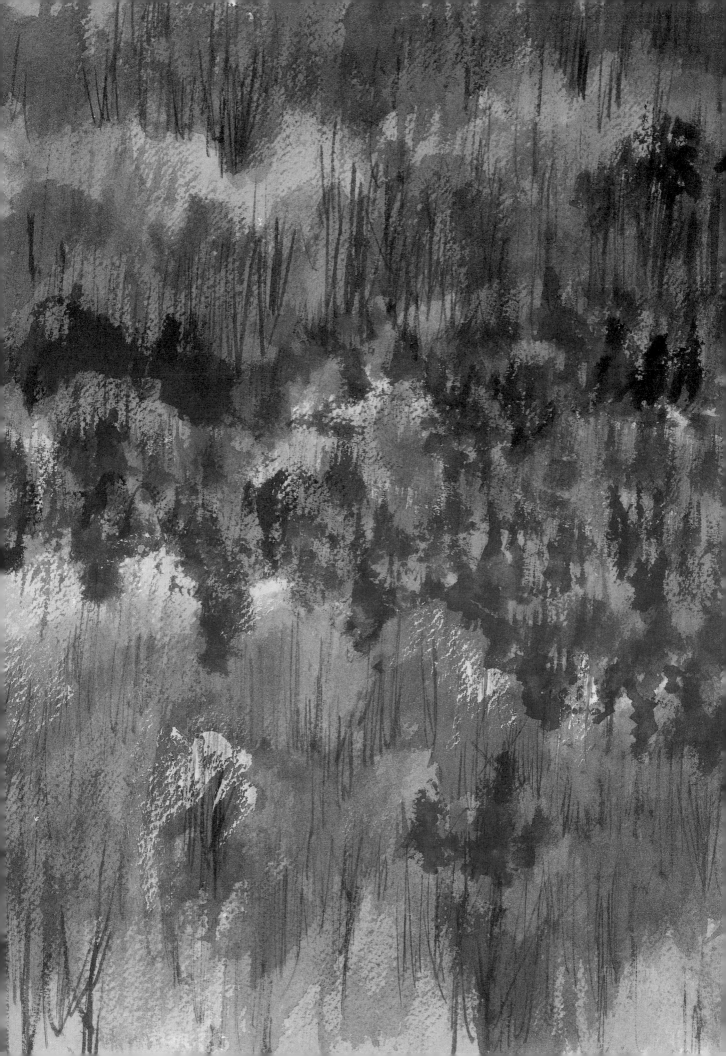

Capturing the Feeling of a Snowy, Overcast Day

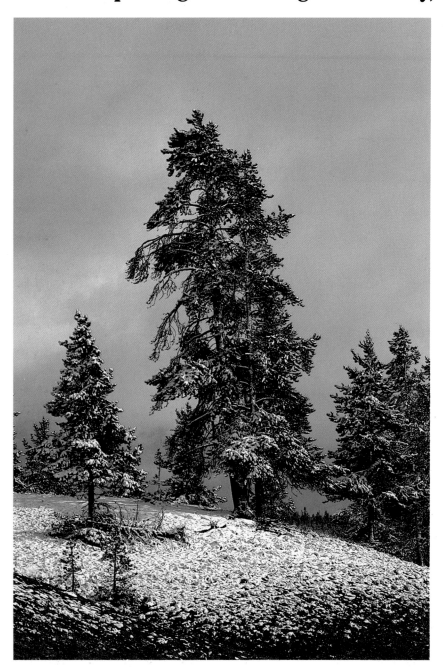

On a cold, overcast day in winter, snow frosts a group of pines set on a hillside.

PROBLEM

Here you want to capture the mood created by the overcast sky, yet maintain the brilliance of the snow. Value relationships between snow and sky can be extremely difficult to capture.

SOLUTION

Instead of concentrating on the patterns formed by the snow, begin with the sky. To pull these two areas together, the wash used for the sky can pick out shadows in the snow.

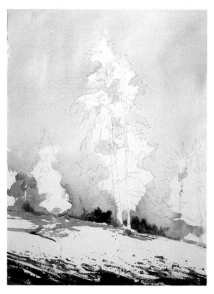

STEP ONE

After you sketch the scene, wet the area above the horizon and lay in the sky with a graded wash. Don't feel bound to match the colors that you see exactly. Here, for example, the purplish wash immediately creates the feeling of a cold winter day. Intensify the wash close to the horizon, and put in the small trees in the background. Put down the dark brown foreground with diagonal strokes, leaving the white of the paper to indicate the snow-covered hillside.

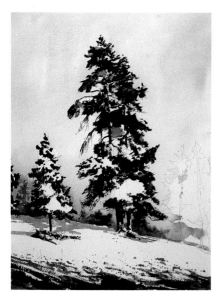

STEP TWO
Continue to develop the darkest values, painting the trees closest to the foreground. Leave some of the paper untouched to suggest how the snow hugs the branches. As you paint, simplify the shape of the tree as much as possible—there's already enough going on here.

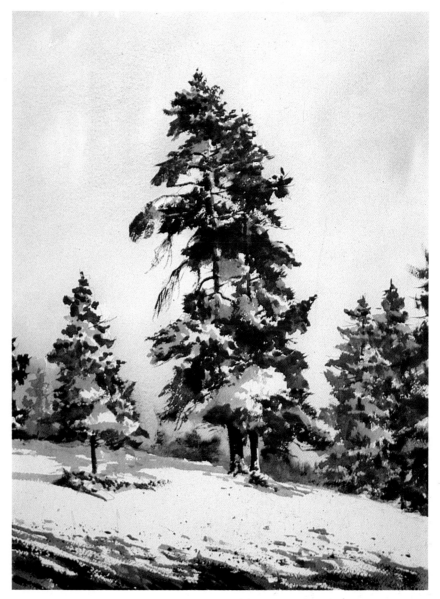

STEP THREE
Using slightly lighter hues, finish painting the trees that lie in the background. Analyze how the light reflects off the masses of snow in the branches, and paint in their shadows. As you work, keep in mind the direction of the light, building up the shadows in a logical way.

FINISHED PAINTING (*overleaf*)
When you look closely at the branches of the trees, you can see how many colors have been used—very few of them greens. Browns, ochers, and blues are much more resonant than most greens, and help convey the brooding quality of the purplish winter sky.

The purple wash used to depict the sky and the shadows on the ground pull the two areas together. The portions painted wet-in-wet seem much softer and farther away than the area just beneath the tree.

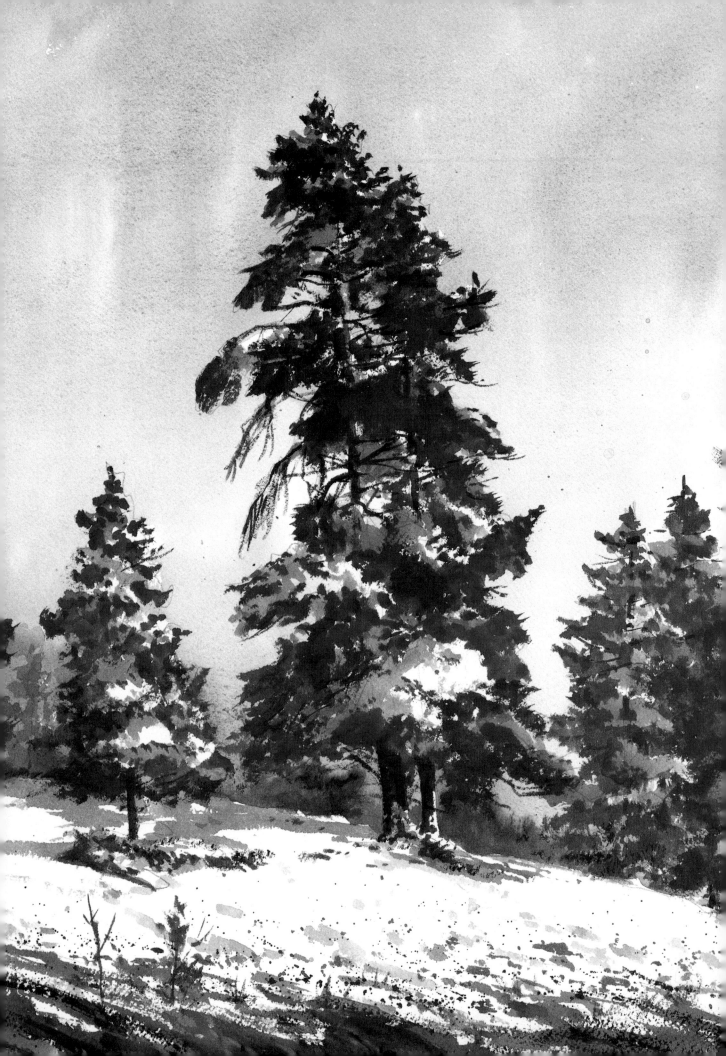

Using Pure White to Pick Out Patterns

PROBLEM

They're really isn't much to hang onto here. Everything in the background is soft and muted, and the pine needles in the foreground are obscured by snow.

SOLUTION

Make the snow dominate your painting. First work out the subtle gradations in the background, saving the snow for the final step.

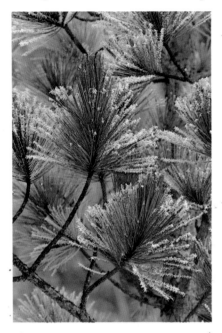

Seen at close range, these pine needles lie under a heavy, thick coat of snow.

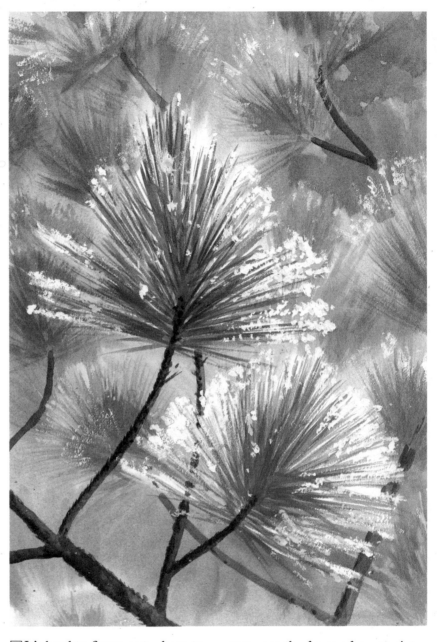

☐ It's hard to figure out where to begin because, except for the snow, everything is closely related in value. If you look closely, though, you can see the directions in which the masses of needles move. On wet paper, lay in the background with muted colors, following the radiating pattern of needles spreading out from branches. Next, work on the dark needles closest to you.

The patterns formed by the snow are the focus of your painting, so think them through before you begin. At first the whites seem equally important, but if you look carefully, you'll see that only those in the foreground really stand out. Paint them first, using gouache; to suggest how the snow settles, dab the paint onto the needles. For the snow in the background, use a brush that is almost dry, moving it quickly and lightly across the paper.

Mastering Complex Geometric Patterns

PROBLEM
Capturing the beauty of these patterns is just part of the problem. You'll also want to depict the interplay between the raindrops and the web, and achieve a sense of depth.

SOLUTION
With a complicated subject like this one, it's essential that you find a consistent approach before you begin to paint. Figure out how the needles have fallen. You'll want to paint those on the bottom—the darkest ones—before you move close to the surface. Mask out the lightest needles, then develop the dark background.

☐ When you begin to paint the complex background, you'll quickly discover that it's impossible to depict everything that you see, so concentrate on rich color. Keep the darkest areas near the corners of the painting; in the center, use cool, muted tones. For the intermediate values—the orange-brown needles beneath the very lightest ones—use gouache; its opacity provides a strong contrast to the transparent quality of the needles resting on top. Work loosely, constantly following the pattern that the needles form. Next, remove the masking fluid and lay in the lightest needles. Start with pale washes, gradually adding detail. Finally, broken dabs of bright white gouache suggest the shimmering raindrops that rest on top of the web.

NOTE
Observe how the complex layering of darks and lights works in this painting. The brightly colored needles that were masked out first spring into focus; painted with clear, brilliant green and yellow, they rest on top of the orangish-brown needles rendered in gouache. At the very bottom, the murky deep brown successfully conveys a feeling of depth.

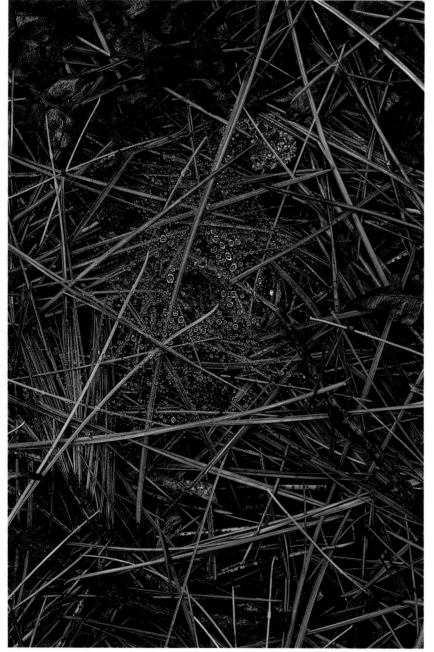

Raindrops hover on fallen pine needles and atop a delicately woven spider's web.

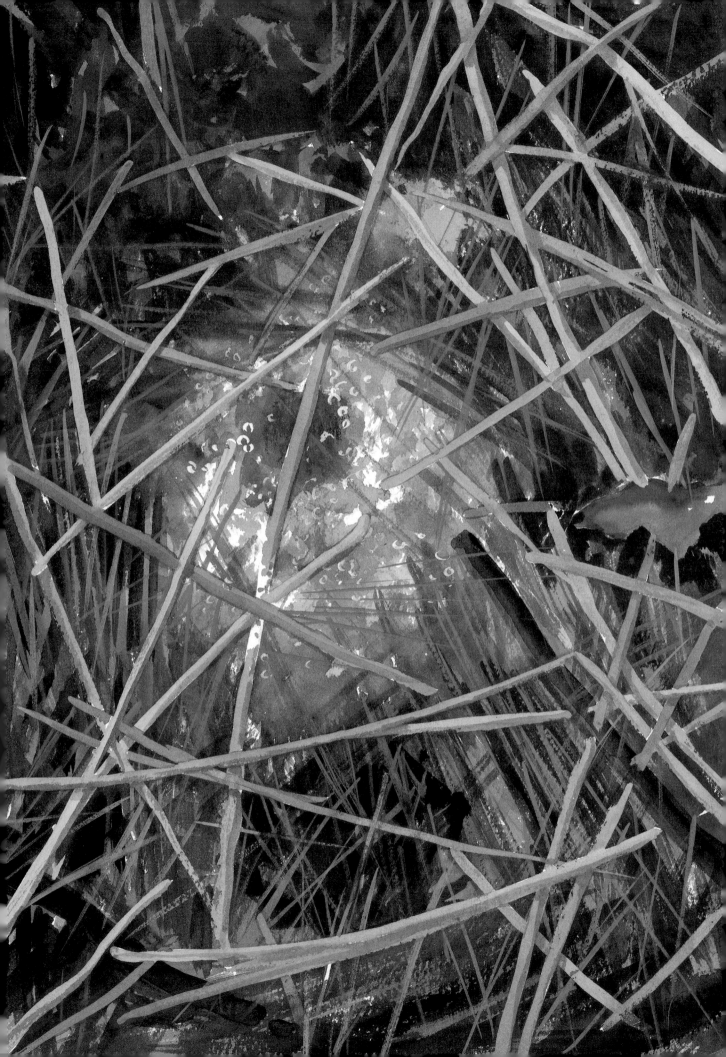

Painting a Complicated Scene Set Near Water

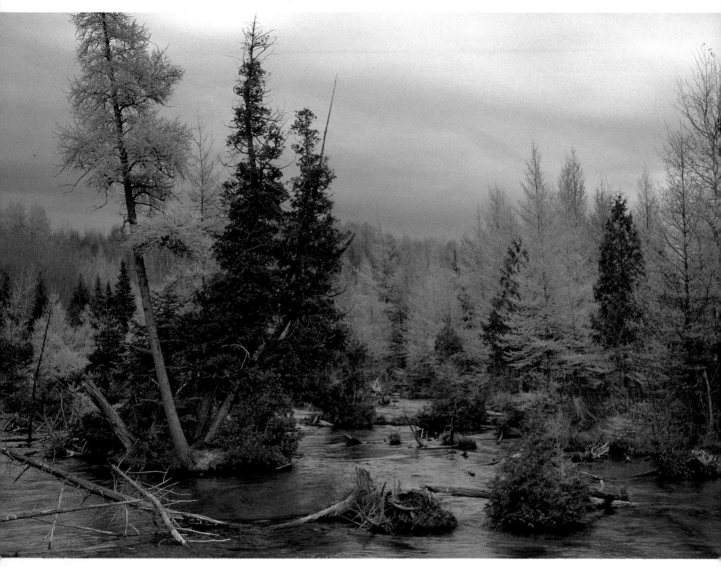

PROBLEM

Sometimes there's so much happening in a scene that you don't know quite where to begin. That's true here—there's an overcast sky, radiant fall foliage, and the water.

SOLUTION

Complicated scenes like this are easiest to handle using a conventional light-to-dark approach. Paint the sky first, then the background and foreground.

Close to a river's edge, larches crowd together, casting their reflections in the water.

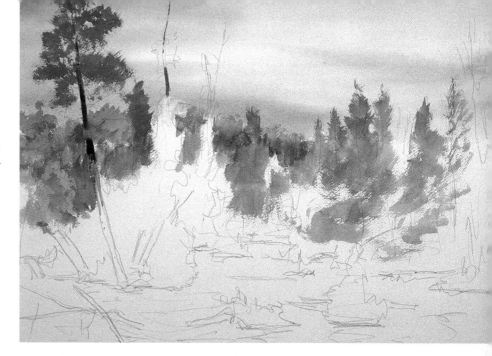

STEP ONE

When a scene is this complex, sketch it fairly carefully, indicating all the major parts of the composition. Since the cool, overcast sky is so important in establishing mood, set it down first. Wet the entire sky, then begin at the top with the lightest areas. Add blue near the tree tops while the other washes are still wet. Next, after the sky washes have dried, paint in the light orange trees and set down a mauve wash behind them to suggest the distant landscape.

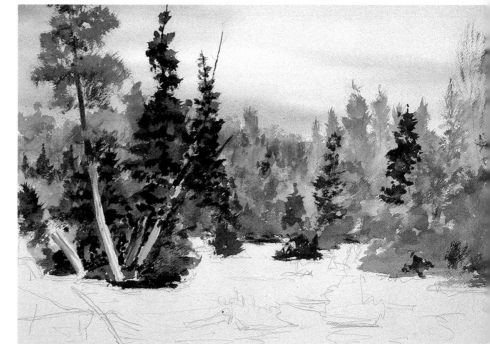

STEP TWO

As you begin to introduce darker values, try using a lot of mauve and gray to paint shadows and details—these colors strongly suggest the smoky quality of an overcast day. After the middle values are laid down, paint the dark green trees near the water.

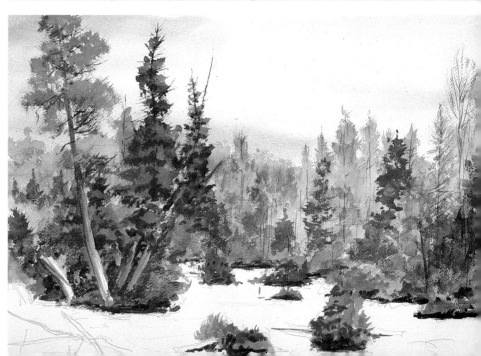

STEP THREE

Before you start painting the river and the reflections in the water, add detail and texture to the trees. Look closely at the values you've established; often you'll find an area you've neglected that seems too light or too dark. Here, for example, the mass of trees on the right was too light. Darkening them helps balance the rest of the painting.

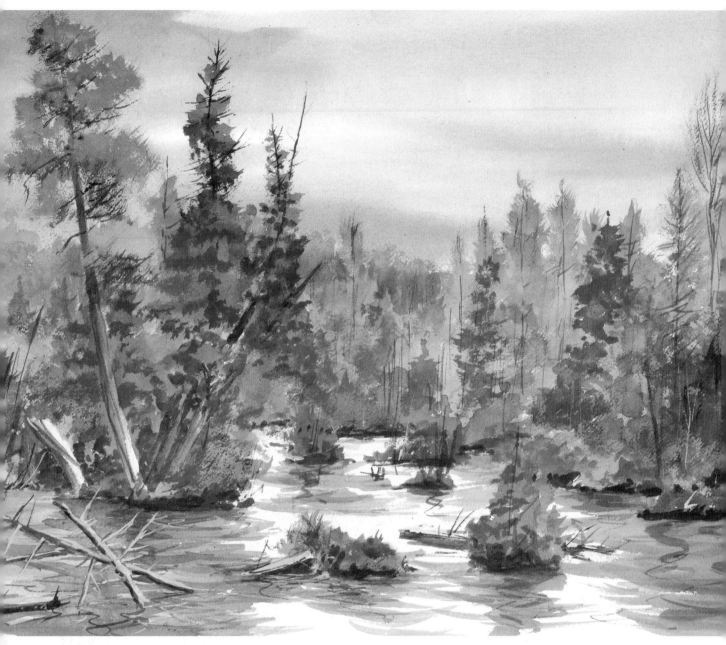

FINISHED PAINTING

Almost everything that makes this painting work happens in its final stages. Look at the painting and the photograph of the scene on the previous pages to see how important your interpretation of a subject is. In the photograph, the water is really pretty much the same color throughout, but if you paint it with a uniform wash, you're going to weigh your painting down. Instead, try and figure out what the painting needs to keep it alive. Here a lot of white paper is left exposed. This not only sharpens the perspective—the white area zooms back toward the horizon—but it also suggests how the sun and water interact. To indicate the areas of water to the left and right of the white area, use a wet-in-wet technique, laying down a smoky wash first. Then, while the paper is still wet, paint in the reflections. Finally, in the lower left corner paint in the branches of the dead wood.

Rendering Intricate Macro Patterns

PROBLEM

It takes a lot of curiosity and creativity to detect the myriad patterns that lie in minute objects, and a bold touch to paint them like the giants they really are.

SOLUTION

It's all too easy to become tense and tight when you're painting something tiny. To stay loose, a good preliminary sketch is essential. Take a lot of time drawing the outlines of the needles before you begin to paint. Work on a large sheet of paper and magnify your subject several times.

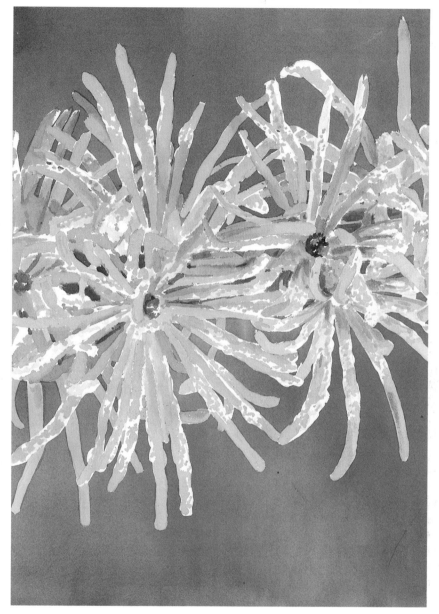

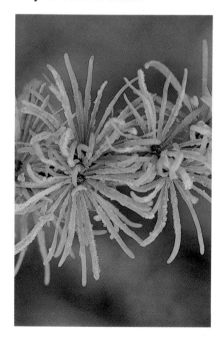

Not much more than an inch long, these frost-encased larch needles create an overpowering impression when seen up close.

☐ You'll never be able to paint around the complex pattern formed by these needles, so mask them out when you've completed your sketch. The needles are so lively that you'll want to downplay the background—use a flat wash. Wet the paper with a sponge, then drop in ultramarine and yellow ocher, working the paint over the surface of the paper. Once you've removed the mask, begin to paint the needles. Here they're rendered in yellow ocher, cadmium orange, and Hooker's green, with just enough white areas left clean to suggest the frost. In some places, the pure white paper may seem too brilliant, and may even detract from the power of the needles. Use a wash of cerulean blue to tone down the discordant areas.

Capturing Light and Shade in Macro Patterns

PROBLEM

The dramatic pattern these spines etch out seems simple at first, but it's really made up of a complex play of light and dark. If your contrasts aren't bold enough, your painting won't have any life.

SOLUTION

Paint all of the darks first, then pick out the lights using gouache. To convey the needlelike feel of the spines, your brushwork must be strong yet precise. Start by painting the background, both the light vertical ridges and the dark areas that lie between them.

The sharp gray spines of a saguaro cactus shoot out from its thick, succulent trunk.

☐ These spines are growing out of thick, columnlike ridges that protrude from the saguaro's trunk. To make this relationship clear, paint the trunk a little lighter than it actually is; if it's too dark it will recede and the spines will seem to be dangling on threads against a dark, distant backdrop. Vary your greens a little too, to suggest what you can't really see, the texture of the trunk.

Next, lay in the dark bumps in the center of each group of spines; then wait until the paper's dry before you tackle the spines. The success of your painting is going to rest on how well you capture their light and dark patterns, so work with just three values—one light tone, one middle one, and a dark. Finally, add a few spines with a dry brush, then apply a blue wash to cool down the shadows that flitter over the spines.

Picking Up Patterns Formed by Middle Values and Highlights

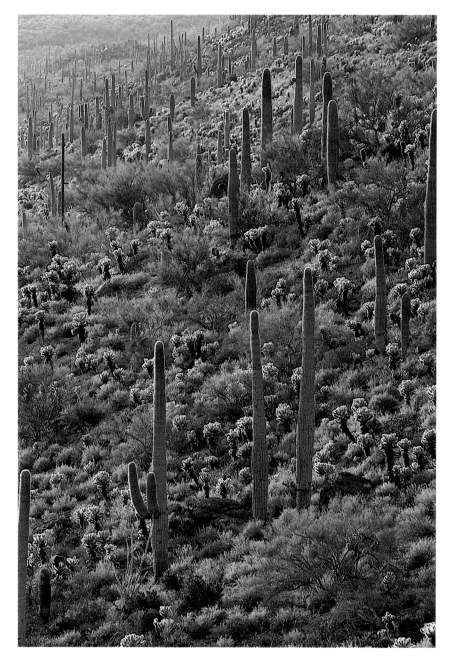

PROBLEM

This is an awfully confusing scene. Even though there are lots of strong verticals and light areas, they create very little pattern, making it hard to organize a painting.

SOLUTION

About the only way to make this kind of scene work is to focus on what you see and capture whatever pattern exists. Concentrate on highlights and try to figure out the pattern they form.

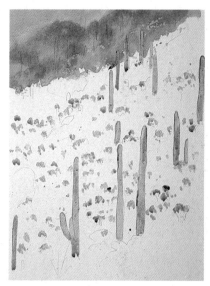

STEP ONE

To convey the time of day and the direction of the sunlight, rely on highlights. Mask these highlights out as soon as you've finished your sketch; if you paint them last you can control their brilliance. Now move on to the hazy area in the upper left corner. Instead of using a flat wash, develop this area with a variety of values and colors to suggest texture.

Late in the afternoon in the Sonoran Desert, these saguaro cacti and the flowers beneath them stretch as far as the eye can see.

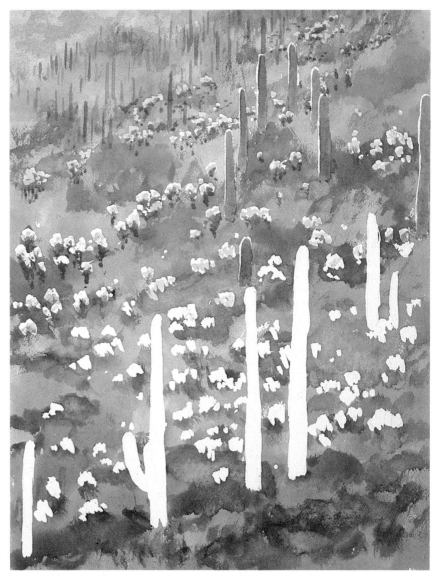

STEP TWO
Working from light to dark, build up the entire surface of the painting. You're working mostly with middle values here. To keep them from seeming bland and uninteresting, continue to use a variety of colors as you explore the subtle gradations of light and dark that you see. What's important here is catching the pattern that the lights and darks create.

STEP THREE
Remove the masking fluid. As you begin to paint the cacti and flowers, remember to leave the areas that catch the afternoon sun white. What you're setting up is a strong feeling of backlighting. The cacti in the foreground are worked with a slightly deeper value than those that lie behind them.

FINISHED PAINTING
Painted with cool, hazy colors, the cactus-filled background is separated from the middle ground by a diagonal ridge of flowers. But the division doesn't seem artificial since some of the cacti that are rooted in the middle ground extend up into the rear zone.

Like the rest of the painting, most of the detail in the foreground is worked in a range of middle values. Yet even though few strong darks or lights are employed, a rich and interesting texture is achieved by breaking up all the masses of color with lively brushwork.

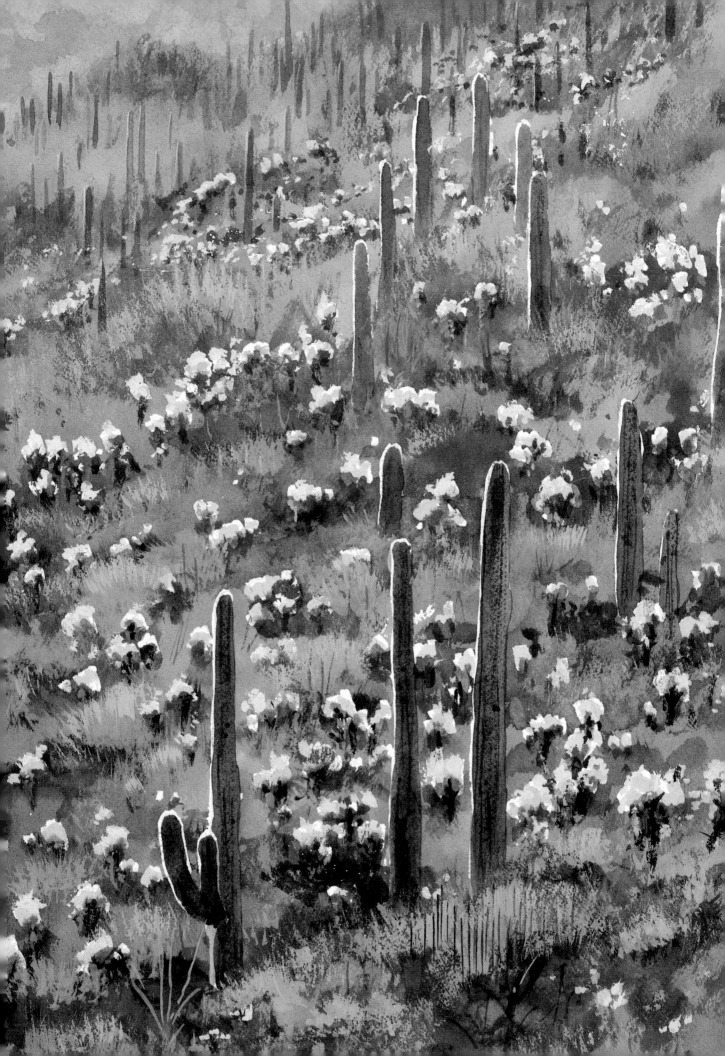

Suggesting the Lacy Feeling of Delicate Foliage

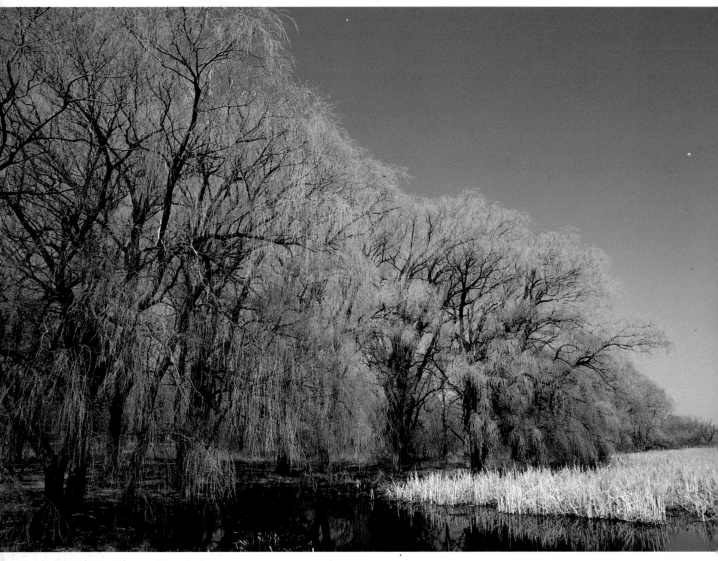

PROBLEM

Weeping willows are large and massive, yet their branches and leaves are soft and graceful. Capturing these qualities simultaneously is tough.

SOLUTION

Before you paint the delicate leaves, work out all the other elements. The foliage can be added last, using opaque gouache.

Set against a deep blue sky on a spring afternoon, these weeping willows sweep back dramatically toward the horizon.

STEP ONE

First sketch the scene, then lay in the sky with yellow ocher, ultramarine, and cerulean blue. Although at first the sky appears to be fairly uniform in color, note how it becomes lighter gradually near the horizon; use a graded wash to show this progression. Work quickly; if the paint is applied slightly unevenly it will appear more lifelike.

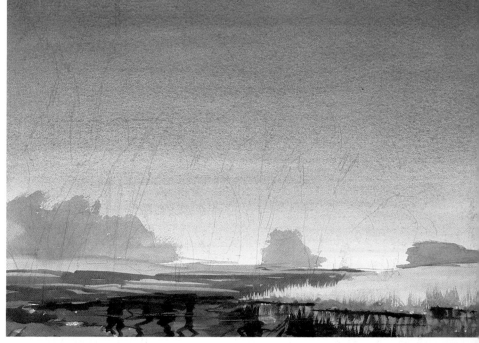

STEP TWO

When you're looking at a scene like this, it can be hard to see beyond the most obvious elements, the trees in the foreground. Try to pick out the most distant masses first, then paint them using cool colors. Next, develop the foreground; it will be the darkest area in the painting, and, consequently, will do a lot to establish your value scheme. You don't have to wait until you've painted the trees to put in their reflections; go ahead and paint them now.

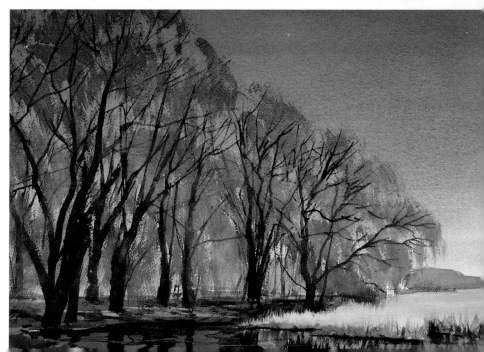

STEP THREE

As you start to depict the trees, concentrate on the trunks, the largest branches, and the large masses formed by the leaves. It's especially important to simplify when you're working with something as delicate as a weeping willow, for you'll never be able to show every little detail.

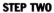

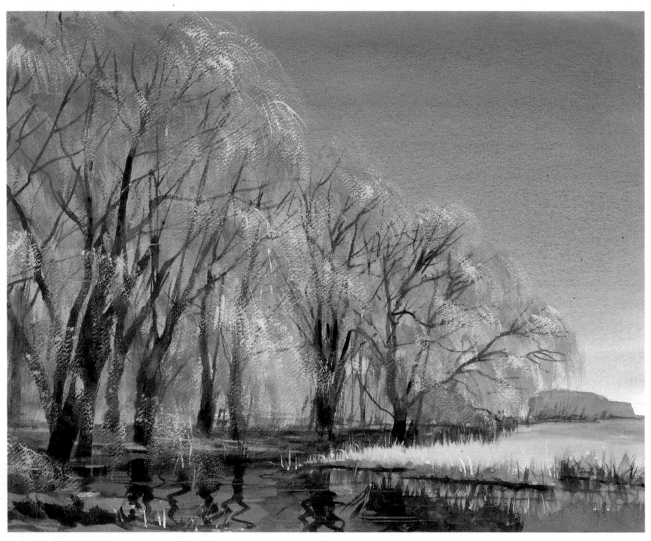

FINISHED PAINTING

Now's the time to emphasize the willow's lacy quality. Since so much of the subject's appeal comes from the way the weight of the foliage bends the branches down, be sure to indicate how they sweep toward the ground. Use a fine brush; moisten it with gouache, then delicately run it across the paper. When the foliage is finished, make any necessary refinements. Here, for example, the tree trunks need to be darkened slightly. Many different types of brushstrokes are used in this painting, ranging from those depicting the fine marsh grass to those showing the bold reflections of the trunks in the water. Note, too, how successful the drybrush technique is in showing the lacy quality of the willow branches. The drybrush

strokes also lighten the fairly heavy trunks; the structure of the trunks is still obvious, but the cascading yellow and green touches veil them, making them less dominant.

DETAIL

When you move in on a detail like this tangle of trunks, branches, and leaves, you can see how important it is to simplify a complicated subject. Through simplification, the overall pattern formed by the weeping willows becomes apparent. When you are working on something as complex as this scene, stop frequently and evaluate your painting. Try to determine when you have achieved a pleasing degree of complexity, then stop before the subject becomes too fussy.

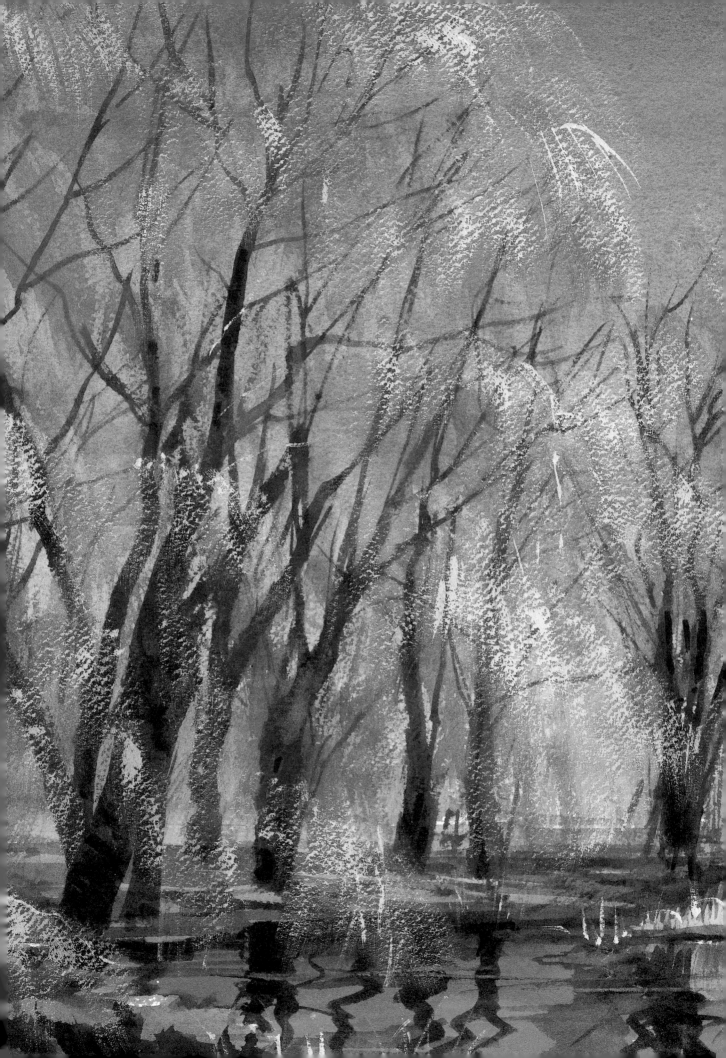

Manipulating Color and Structure to Achieve a Bold Effect

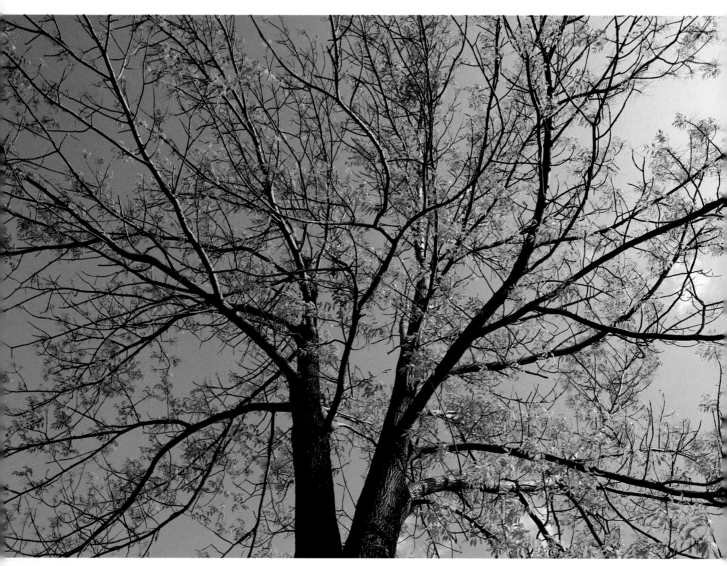

PROBLEM

Don't underestimate the power of what seems at first to be a fairly tame subject. You have to do more than simply paint what's in front of you—you've got to interpret it.

SOLUTION

A good part of the solution lies in composition. Make the crown shoot boldly beyond the edges of the paper, then intensify the strength of the branches and leaves, and lay in a bold sky.

Seen from below, the wispy branches and tender leaves of this tall white ash stand against a slowly moving sky.

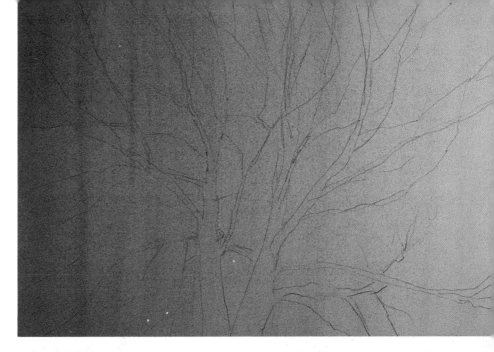

STEP ONE
Draw the tree, concentrating on the main branches and the way they move out toward the edges of the paper. Next, analyze the sky. Unless a sky is filled with dramatic clouds, most people read it as flat blue, but, in fact, its color can vary a great deal; here it's most intense on the left. To render it, turn the paper on its side, and put down a graded wash.

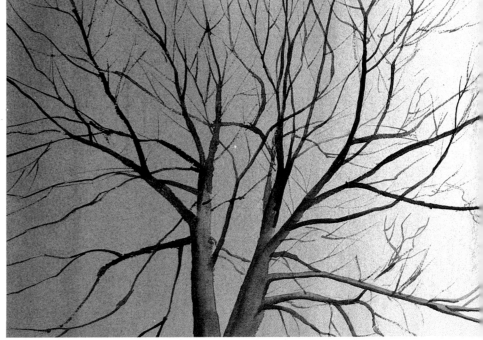

STEP TWO
After the sky wash has dried, paint in the trunk and then start in on the branches. Selecting the right kind of brush makes all the difference when you're rendering delicate lines. Try a lettering brush or a rigger; both are very thin brushes that are ideal for this kind of work. Be careful, though; these brushes—especially the rigger—can be difficult to control. Experiment with them before you start to paint.

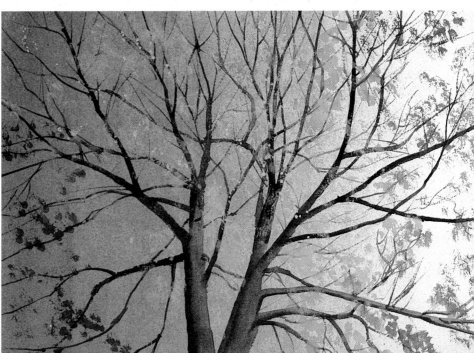

STEP THREE
Analyze the way you've treated the branches. They should look logical—that is, they should relate to one another, with none starting suddenly in midair. Make any necessary corrections, then tackle the leaves. Using gouache, dab paint forcefully onto the paper. Use an old brush, or even a sponge, for this rough work.

FINISHED PAINTING

Pick up the rigger again and fill in the tiny branches between the larger ones and then add texture to the tree trunk. Finally, spatter a few bright dashes of yellowish-green paint over the leaves to make the center of the painting come alive.

ASSIGNMENT

When you're painting trees, you'll discover that every season has its own problems. In spring, when foliage just starts to appear, the leaves are rarely dense enough to form masses. If you paint them in too heavily, you'll lose the suggestion of fresh, young growth, but if you're too tentative, your painting will lack spunk.

Begin by painting the skeleton of a tree—its trunk and branches. Just use one color here, and don't be too concerned with accuracy. Next, take bright green gouache and begin to paint. Try a variety of approaches. With an old brush, dab the paint onto the paper, varying the paint's density and the size of your strokes. Next, try a drybrush technique, and take advantage of the paper's bumpy surface to break up your strokes. Finally, experiment with a small sponge. First soak it with paint and dab it onto the paper, then try it when it's fairly dry. After you attempt each technique, stop and evaluate the effect.

Making a Delicate Tree Dominate a Cloud-filled Landscape

PROBLEM

This ash could easily get lost in your painting. Its branches, twigs, and leaves are so fine that they hardly show at all against the cloudy sky.

SOLUTION

To achieve the effect you're aiming at, play around with colors and values and even with the structure of the tree itself. Emphasize what has to be strong and downplay what seems overpowering. Begin with the sky, then do the background and foreground, saving the tree for last.

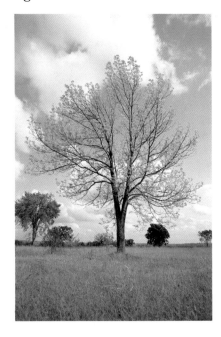

Its springtime foliage just beginning to appear, this white ash rises against a cloudy sky.

☐ The first step toward making this tree dominant is lightening the sky. As you lay in your wash, work around the clouds, then go back and soften the edges of the cloud masses using a brush dipped into clear water. You'll want to capture the shadowy portions of the clouds next; use a gray wash, then soften the contours with clear water.

Next tackle the background and foreground, keeping them simple, with a minimum of detail. The only unusual thing that happens here is the emphasis placed on the ocher grass behind the tree. By making it brighter than it actually is, you pull the viewer's eye away from the sky and right to the base of the tree. Use license with the tree, too, darkening its branches just a bit. Finally, to add the leaves, dab paint gently onto the paper.

Working with Foliage Set Against a Dark Blue Sky

PROBLEM

Since the sky is so important here in establishing the mood of the scene, you'll want to emphasize it, but not at the expense of the tree.

SOLUTION

Go ahead and paint the sky as you see it. By adjusting the values of the greens, you'll be able to make the tree stand out against the dark blue. Because you're trying to increase the drama of the tree and sky, use a simple straightforward approach for the prairie and the hills.

☐ To capture the intense blue at the top of the scene, use pure ultramarine. As you near the bottom, temper its strength with cerulean blue. While the paint is still wet, take a tissue or small sponge and wipe out the clouds, then add their highlights with white gouache. When the blue wash has dried, render the hills and foreground with flat washes of yellow-ocher, Hooker's green, burnt sienna, sepia, and mauve, then go back and lay in a little

A rich blue sky, filled with meandering clouds, sets a dramatic stage for this handsome elm.

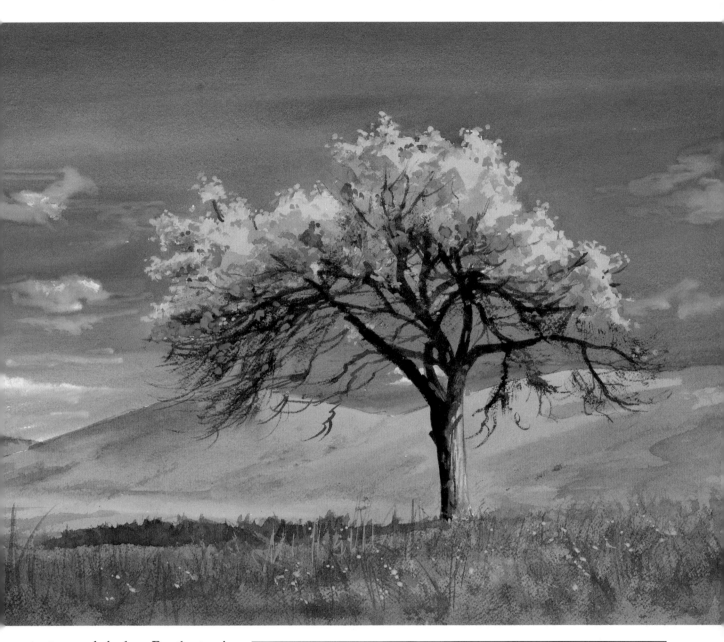

texture and shadow. For the tree's bright foliage, you'll need a strong middle tone to make the leaves stand out against the sky. Dab the paint on, trying to capture how clusters of the leaves cling to the branches. To indicate the shadowy areas on the leaves, use paint just one value darker. Next, render the trunks. Finally, to clarify what's close and what's far away, put in the tall grasses in the foreground with a fine brush.

ASSIGNMENT

Don't be afraid to use strong, dramatic color when a situation calls for it. It's surprising how intensely watercolor pigment can be applied before it loses its transparency.

To learn the limits of the medium, try painting a dark tree trunk. First sketch the trunk, then moisten the paper with clear water. Drop sepia, burnt sienna, and Hooker's green light onto the paper, mixing the colors as you work. Use a lot of pigment, and experiment with varying its density.

In some areas, add a little water to the paper to dilute the paint; in others, apply the paint straight from the tube. You'll discover that only when you use pure, thick, undiluted pigment do you lose the transparency that characterizes watercolor paint.

Learning to Work with Strong Blues and Greens

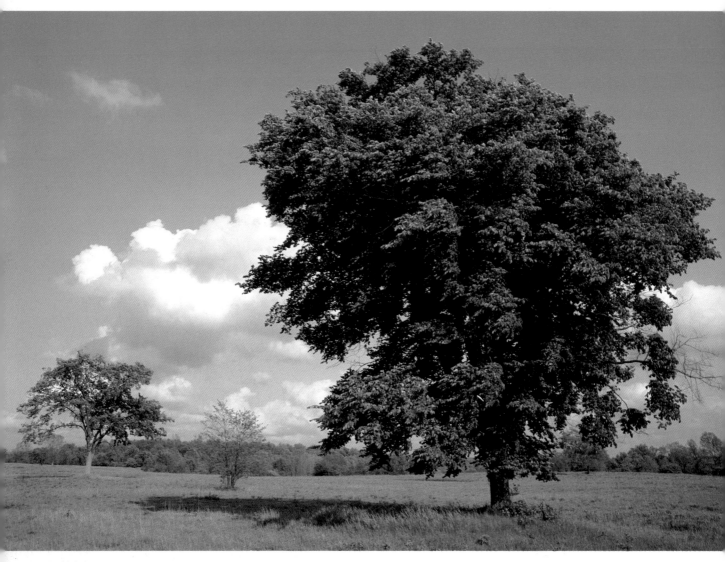

PROBLEM
Deep blues and greens like those seen here go together so naturally that it's easy to forget the problems they pose. They have to be treated with care because their values are so very close together.

SOLUTION
Paint the sky first, then balance the greens you use against it. You'll want to use just a few shades of green in order to keep the picture simple and fresh.

An elm in fresh springtime foliage harmonizes with a deep blue sky.

STEP ONE

Sketch the basic lines of the composition; then begin to paint the sky, leaving white paper to indicate the smaller clouds. Work around the tree in the foreground without being too fussy; eventually the green will cover whatever bits of blue stray into the area of the crown. Next, using pale washes, execute the dramatic cloud formation. Keep the clouds soft; get rid of any harsh touches right away using a brush dipped into clean water. Finally, paint in the trees that lie along the horizon.

STEP TWO

In late spring or in summer, trees like this are fairly easy to capture in paint. Their leaves have pretty much filled out and they form clear-cut masses. Before you begin, think through the main masses you see in the crown. Start with the lightest areas, using just two or three slightly different washes, all based on one green pigment. The key to this step is to keep the masses simple. Next, using broad, sweeping strokes, add a light wash to indicate the ground. While it is wet, start developing the shadow cast by the large elm. Next, add the tree trunk.

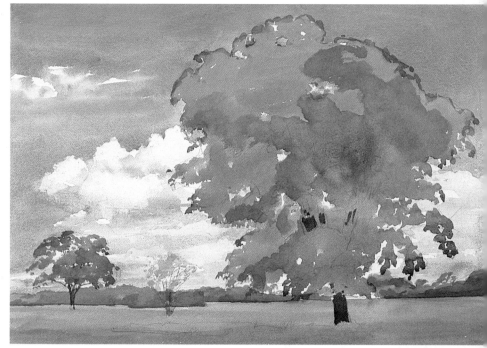

STEP THREE

Just as you did in step two, analyze the way the lights and darks in the crown break up before you start to add the dark shadows, and as you render them, continue to use bold, simple strokes. Next, turn your attention to the foreground. Put down the darkest part of the shadow cast by the tree, then indicate the tall grass growing right in front of the elm. For the grass, use short, up-and-down strokes.

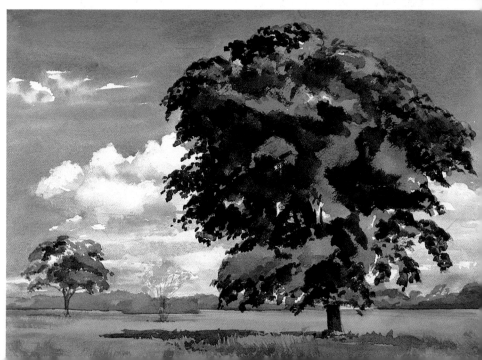

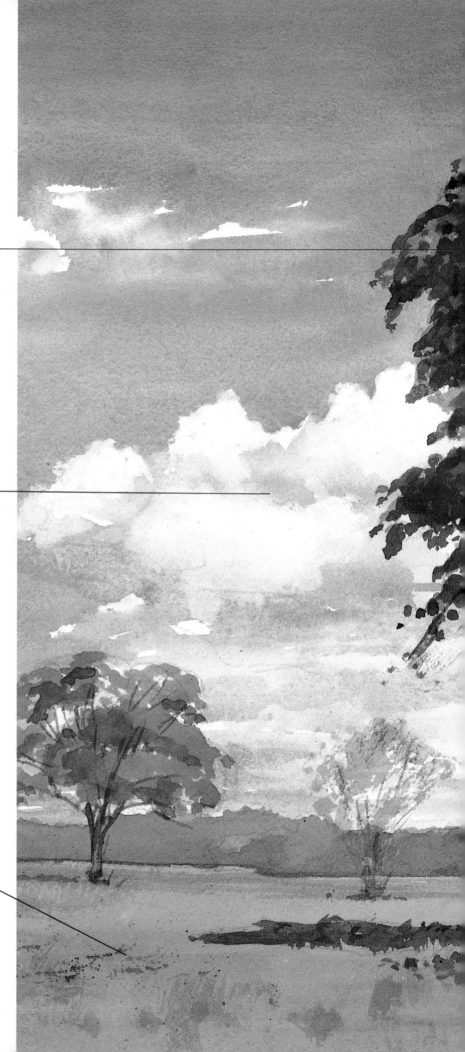

FINISHED PAINTING

In completing your painting, work sparingly. Too much detail now will get in the way of the fresh, uncomplicated scene you've developed. Here spatter small touches on the foreground, add a few fine branches to the large elm, and intensify any shadows that may seem weak.

Here dabs of green break up the monotony of the large dark areas. But since the dabs are in the same color as some of the medium-value green, applied in step two, they don't interfere with the overall harmony of the finished painting.

These clouds are dramatic, yet they appear restrained and don't fight for attention with the rest of the picture. This is, in large part, because of the strong statement the elm in the foreground makes. Its simplicity makes it much more powerful than it would be were it filled with intricate detail.

The spattering applied at the very end is also restrained. Just enough has been added to pull the foreground toward the viewer.

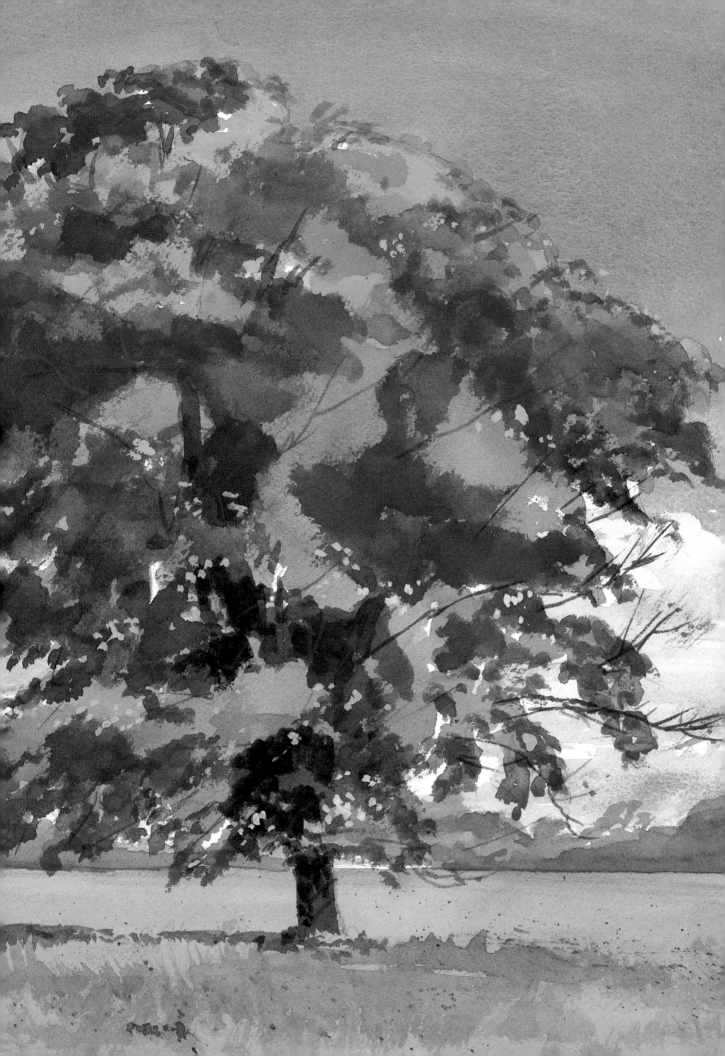

Learning to Focus in on a Landscape

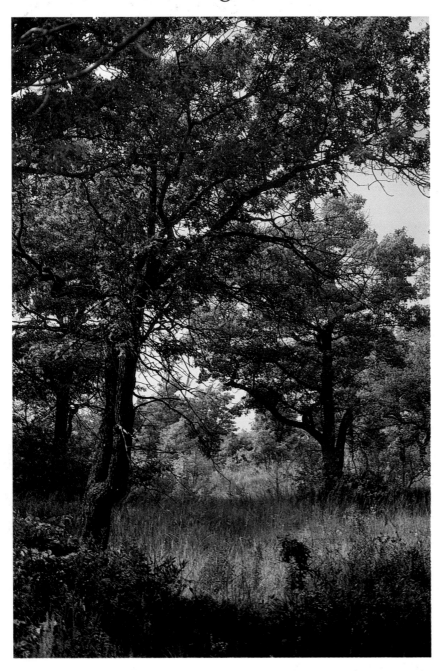

In a field of prairie grass on a September afternoon, these black oaks dominate the landscape.

PROBLEM

Here we've moved in fairly close to the scene, so close that the trees and grass form an almost abstract pattern against the patches of sky.

SOLUTION

Try to minimize the places where the sky shines through the foliage, but don't eliminate them altogether. If you do, your painting will be heavy and dead. For control, use the traditional light-to-dark approach.

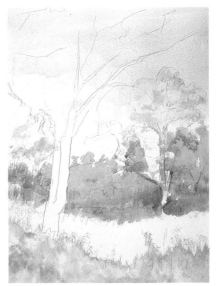

STEP ONE

In a situation like this, packed with dark masses, you've got to learn to look beyond what's in the foreground. Temporarily forget the trees and focus on the sky. Since so much of the composition is taken up by the dark trees, you'll want some bright passages to shine through. In the upper right corner the sky is almost imperceptibly darker than below and to the left. For the lightest parts, just leave the white paper alone. Along the horizon line, lay down the distant trees. Here fairly bright colors are used; they'll be subdued by the washes applied later.

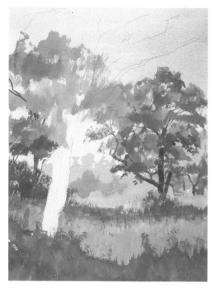

STEP TWO

Now start developing the tree masses in the rear and the foreground. First lay in the brightest areas, then gradually add darker washes, saving the very darkest for last. Since the trees and the prairie grass fill almost the entire scene, don't just concentrate on one area; work over the whole surface. As you paint, remember to simplify the leaf masses. Their lacy quality will be suggested by bits of sky.

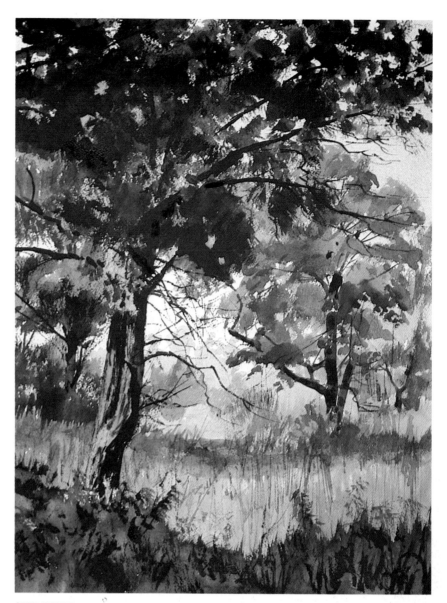

STEP THREE

As you begin to paint the large tree in the foreground, slowly increase the value of your greens. First, work with a green just slightly darker than those you've used previously, then continue to use darker shades. The final ones will be as dark as the tree trunk. Next, turn to detail. Using a fine brush, add the small twigs. Work rapidly, letting just the tip of the brush skate over the paper. Continue using a fine brush to indicate the grasses in the foreground.

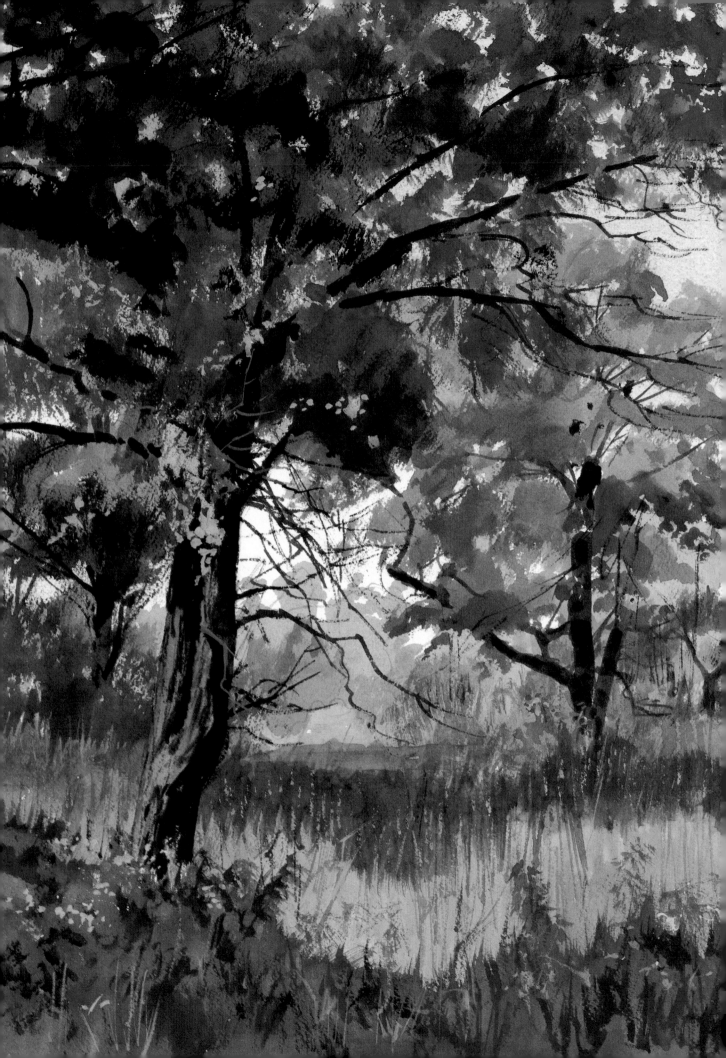

FINISHED PAINTING

The grass that lies under the trees in the foreground is a little weak and has to be darkened. That done, all that's really left are touches of light green detail in the foreground. As a last touch, a few spatters of bright yellow in the lower right corner suggest a group of wildflowers.

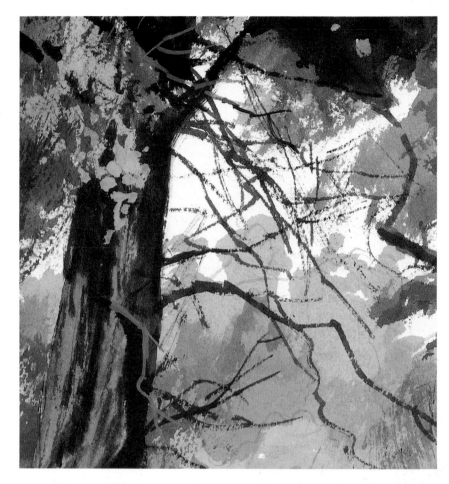

DETAIL ONE

A detail like this points out how strongly greens affect the way we see other colors. The patches of white look fairly stark when they're isolated as they are here, but seen in the context of the whole painting, they appear pale blue. The passages in the background that were painted in step one no longer seem bright; the strong greens have subdued them.

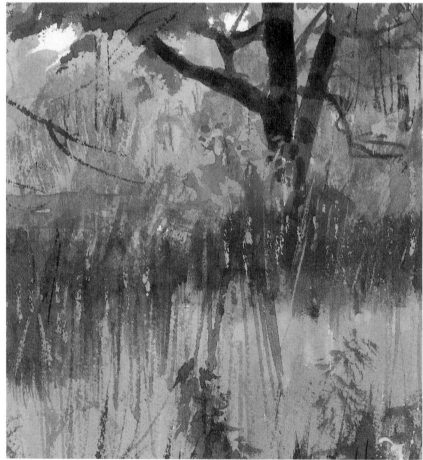

DETAIL TWO

Here's another example of how different colors work with green. The tips of the prairie grass are painted with peach, a color that falls roughly opposite green on the color wheel and that consequently enhances it. Using complementary colors like this is a good way to add accents to a painting that seems too monochromatic.

Working with Contrasting Textures and Colors

PROBLEM
Two elements are fighting for attention and have to be balanced: the rough texture of the walnut bark and the graceful leaf patterns.

SOLUTION
Capture the patterns the leaves form with a careful sketch, then go to work on the bark. Develop its texture completely and then turn to the leaves.

☐ One of the basic decisions you have to make when you work with watercolor is when to mask out an area. As a rule, it's only necessary when you want to keep a clean, crisp edge. Here, the bark is so roughly textured that it won't matter if the leaf edges are a little indistinct, so masking isn't important.

To capture the bark's coarse, uneven texture, use all the techniques you can muster. Start with a wet-in-wet approach, dropping in shadows and rough passages, then begin to experiment. Although it wasn't necessary here, if you want you can scratch some areas out with a razor or smear the paint with your finger or a piece of cloth.

Rendering the leaves is easy because of the effort taken with the preliminary drawing. Start with the darkest leaves, picking out the pattern they form, then go on and paint the middle- and light-tone ones.

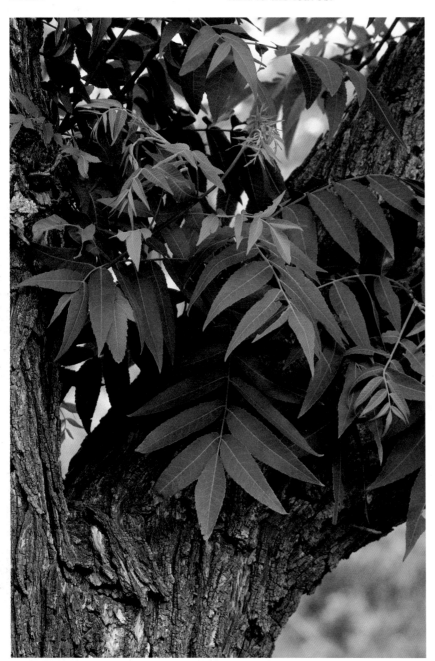

ASSIGNMENT
Look for a branch that has fallen to the ground, preferably one with lots of overlapping leaves. At home, prop the branch against a wall, then begin to sketch it. Do a careful drawing, paying attention to the major twigs and stems and how they connect, but don't get overly concerned with minute details.

When the drawing is completed, mix a couple of warm and cool greens, then begin to paint. As you work, concentrate on two things: the patterns that the leaves form and the shadows that the leaves cast on one another.

The drooping leaflets of an Arizona walnut tree cascade down its rough, craggy bark.

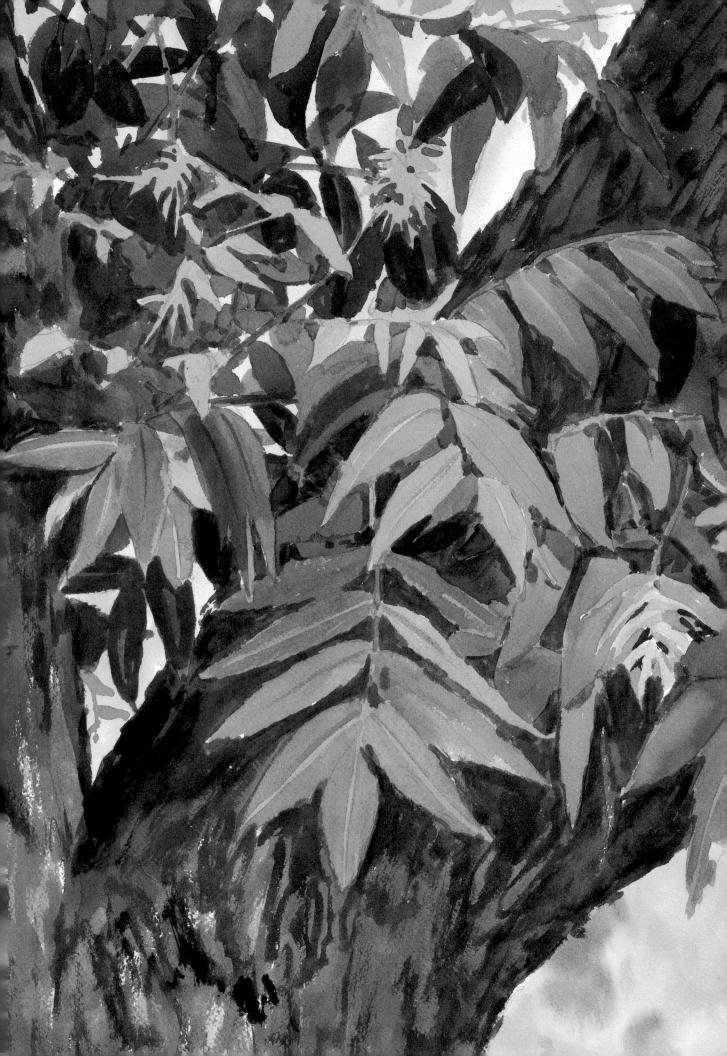

Discovering Color in a Seemingly Monochromatic Subject

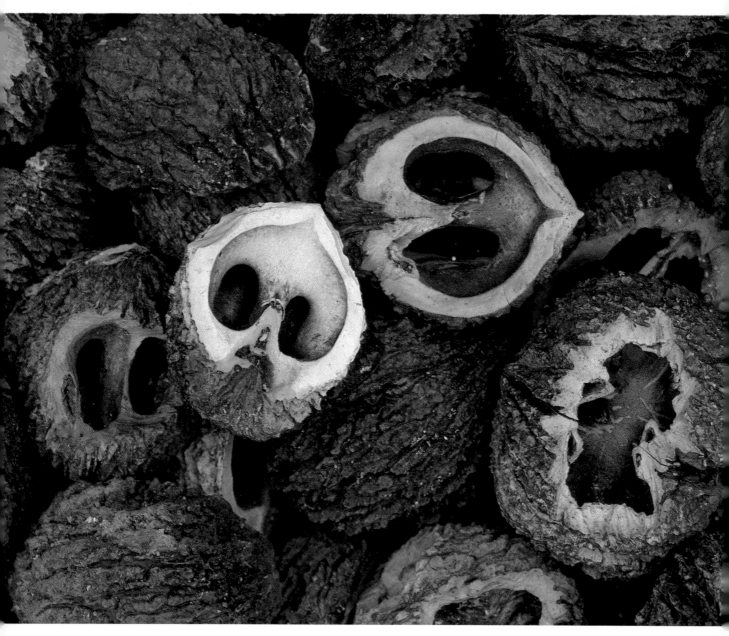

PROBLEM
It's easy to approach a subject like this thinking in terms of just two or three colors. If you do, your painting will end up leaden and uninteresting.

SOLUTION
Search for the colors that lie hidden in the scene, then load your palette with blue, purple, and yellow, as well as the expected grays and browns.

☐ Sketch the walnuts carefully; your drawing should be rich with detail, and should even portray the texture of the nuts' surfaces. Next, reinforce your sketch with very dark paint, here sepia and Payne's gray; you can work in India ink if you want crisper, darker lines. What you're doing is creating an armature on which to build your painting.

As you lay in middle-tone washes over the dark areas of the

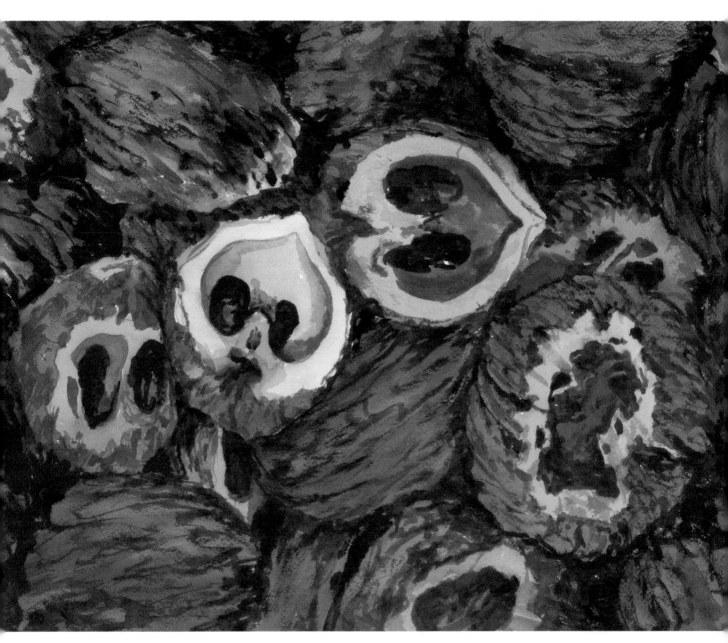

Cracked open by hungry squirrels, black walnuts lie in piles on the forest floor.

walnuts, explore subtle shifts in color. Mauve, cerulean blue, and burnt sienna come into play here. For the light interiors, mix yellow ocher with burnt sienna. Once all the colors and values are laid in, go back and add detail. Since your washes will have softened some of the dark lines you established first, complete the painting by sharpening them with more sepia and gray.

ASSIGNMENT

Pile a group of pinecones on a table, then sketch them. Since your drawing is going to be the backbone of your painting, you'll want it to be accurate and to have a fair amount of detail. Next, take a fine brush and cover the lines of your drawing with India ink, then let the ink dry.

Analyze the pinecones, looking for subtle gradations in color. Exaggerate those that you see as you begin to lay in washes of paint over the India ink. As the washes dry, go back and reinforce the color in some areas. Don't worry about overworking your painting; the ink isn't going to run or fade, so it gives you a lot of freedom to experiment.

Contrasting Delicate Lights with Heavy Darks

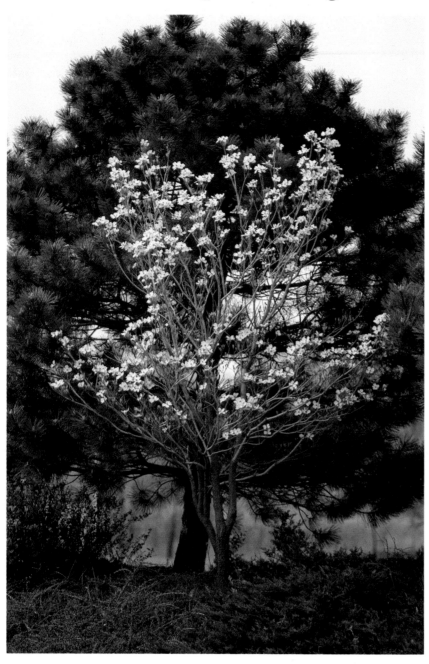

*In late spring, a dogwood's brilliant
pink flowers form an unexpected
pattern against a dark, massive conifer.*

PROBLEM
You don't see many scenes like
this—the juxtaposition of the dog-
wood and the conifer seems al-
most contrived. And if something
looks contrived in nature, it's hard
to make it seem natural in a
painting.

SOLUTION
Paint almost the entire scene as if
the dogwood weren't there, sav-
ing the blossoms for the very
end.

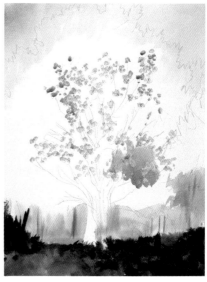

STEP ONE
Like most conifers, this one's
crown has a strong shape. Cap-
ture it in your drawing. Next,
mask out the dogwood blossoms.
You can't mask each one, so try
to simplify them, picking out the
pattern they form. Next, with a
pale blue wash, paint the sky. To
depict the softly focused area
under the trees, use a lavender
wash, and when it's dry, prepare a
slightly darker wash to suggest
the undergrowth. Here some of
the dark lavender paint is also
applied to show a mass of the
dogwood blossoms. Finally, de-
velop the foreground.

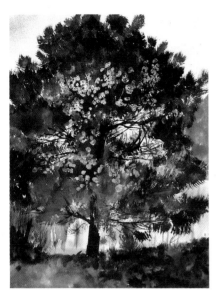

STEP TWO

When you're dealing with something as powerful as this dark tree, the way you apply your paint is critical. Your brushstrokes have to be forceful and must indicate the effect created by the needles. Here a flat, fan-shaped brush is ideal. Load it with paint, then move it decisively over the paper. Pay attention to the shadows on the undersides of the branches; to render them, use slightly darker paint. Note here how miniscule bits of paper are left white, helping break up the massiveness of the crown.

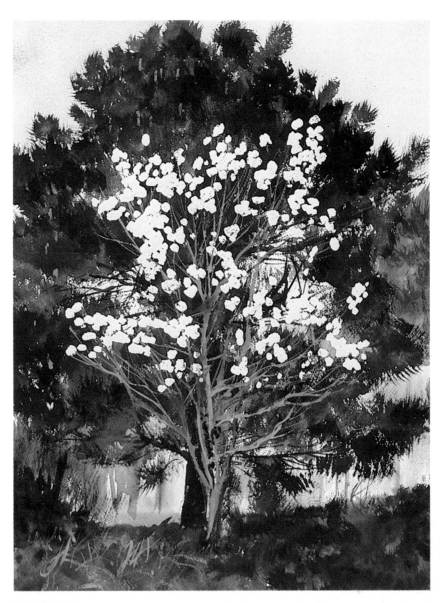

STEP THREE

Complete the conifer, then dab on touches of brown to suggest its cones. Paint the trunk and branches of the dogwood with opaque gouache, here a mixture of purple, white, and a little yellow ocher. The trunk has to be dark enough to seem lifelike, yet light enough to stand out against the conifer, so do some test color swatches before you begin to paint. For the branches, use a fine brush, pulling it quickly over the paper. Be sure that you get across the feeling created by the tangle of branches; have your strokes cross one another, and keep them fluid and lively.

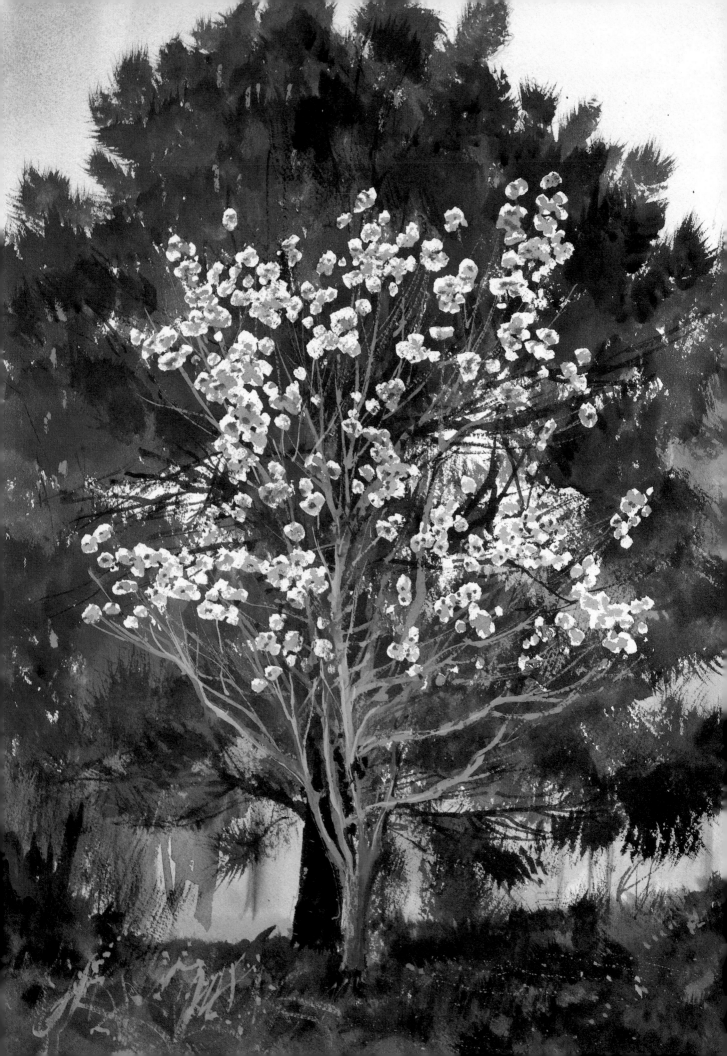

FINISHED PAINTING

Remove the masking fluid. For the blossoms, work in layers, beginning with a very pale shade, then adding slightly darker, richer details. Unlike the flowers, the small twigs and branches are mostly one color, but touches of dark brown break up any monotony; for the larger branches and the trunk, two shades hint at how the sun is hitting the dogwood tree.

Even though the ground in front of the dogwood tree is relatively unimportant in this composition, it has a fair amount of detail, such as the spatters of light green. This type of texture is important here; it balances all of the pattern formed by the dogwood blossoms and the conifer.

DETAIL

Don't be afraid of dramatic contrasts between darks and lights. Here the light pink flowers stand in bold relief against the dark tree, yet in the context of the scene they seem natural.

Notice how the flowers unfold in layers of color—the very palest pink lies toward the rim, with progressively darker shades toward the center. When you're working from light to dark and you want to keep the shifts in color clean and crisp, wait until each layer is dry before you add the next one.

Establishing the Texture of Pure White Flowers

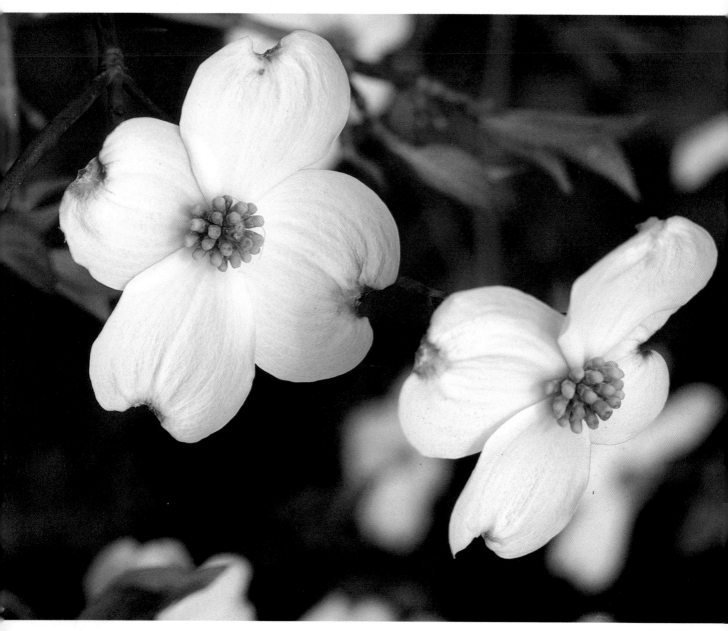

PROBLEM
The texture of pure white objects is revealed by very subtle shadows and highlights. These fine gradations can be extremely difficult to capture.

SOLUTION
Go ahead and exaggerate the texture of the flowers with a gray wash. If you keep the background dark enough, the flowers will look white.

☐ After you draw the flowers, mask them out to keep their edges crisp and clear. Next, paint the background. Working with a wet-in-wet technique, lay in rich, intense color—darker color, in fact, than that which you see. Mute the unfocused flowers and leaves by darkening them slightly and softening their edges. Next, peel off the masking solution and begin work on the blossoms. With broad, sweeping strokes, apply a

In early spring, a flowering dogwood tree bursts into bloom, heralding the leaves that will soon appear.

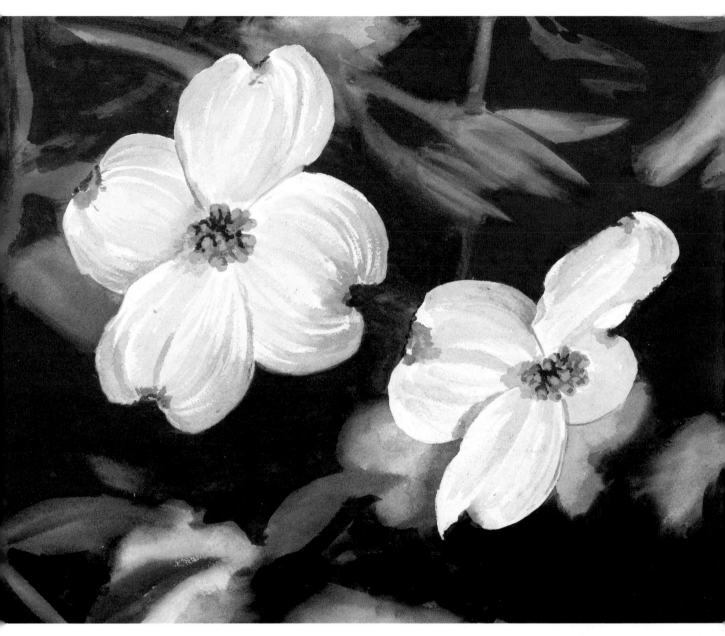

light gray wash to indicate their fine surface ridges. Your brushwork will convey how the blossoms move in space; for example, the gray wash used on the bottom petal of the flower at the left shows how it moves backward, toward the flowers that lie beyond it. Finally, render the tiny flowers in the center of each blossom, and lay in the pink and gray touches on the edge of each petal.

ASSIGNMENT

Set up two still lifes, one with a pale flower set against a dark background, the other with a dark flower set against a light background. Sketch both subjects.

When you turn to the pale flower, you'll want to mask it out to keep its edges crisp. Next, lay in the entire background. As you begin to paint the flower, you can gauge how dark its surface detail should be to harmonize with the backdrop.

With the dark flower, the procedure is just the opposite. Paint the flower first. Once you have completed it, you'll be able to decide how light or dark you want the background to be.

Capturing the Structure of Delicate Flowers

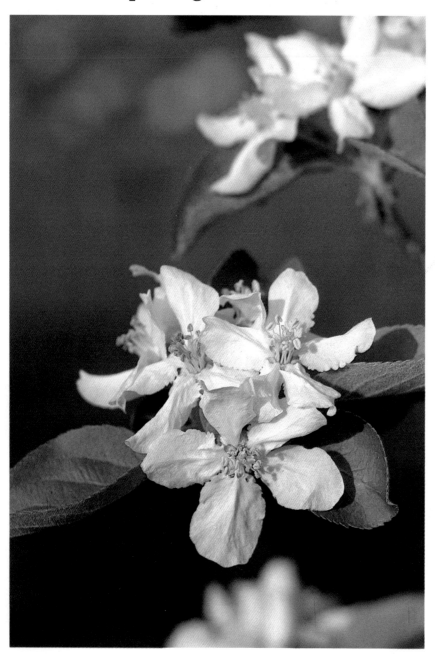

PROBLEM

When you're dealing with floral subjects, it's often hard to convey their structure, especially when the flowers are pale and delicate.

SOLUTION

Let your drawing shine through the transparent watercolor. It will add a subtle sense of order to the finished painting, and a graceful touch as well.

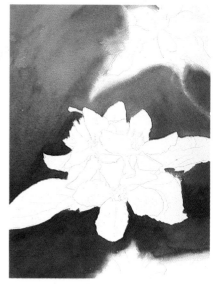

STEP ONE

Execute a careful drawing; remember, it's going to be part of the finished work. Next, wet a brush with clear water and moisten the area around the flowers. As you drop in your paint and begin to lay in the background, keep the edges around the flowers in the foreground sharp. The background here is made up of alizarin crimson, Hooker's green light, and Payne's gray.

In early spring, showy pink apple blossoms catch the warmth of late afternoon sun.

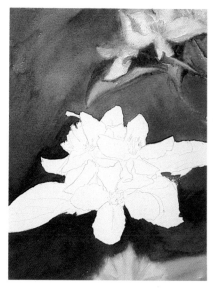

STEP TWO

Finish the background, softening any harsh areas with clear water. Next, paint the softly focused flowers and leaves in the foreground and background using cadmium red, alizarin crimson, Hooker's green light, yellow ocher, and cadmium orange. The colors should look diffused and hazy, yet not too soft; they're easier to control if the paper is just slightly wet.

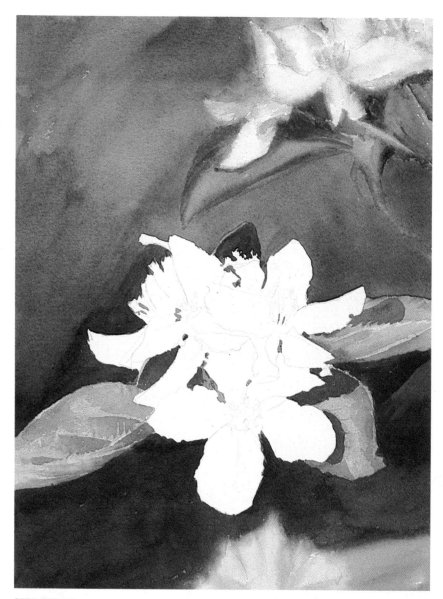

STEP THREE

Leave the center of interest—the sharply focused apple blossoms—till last. First, render the leaves that surround them. Don't be too exacting here; the leaves shouldn't pull attention away from the flowers. Apply a wash of Hooker's green light, then add yellow ocher, new gamboge, and burnt sienna to your palette as you depict their shadows and details.

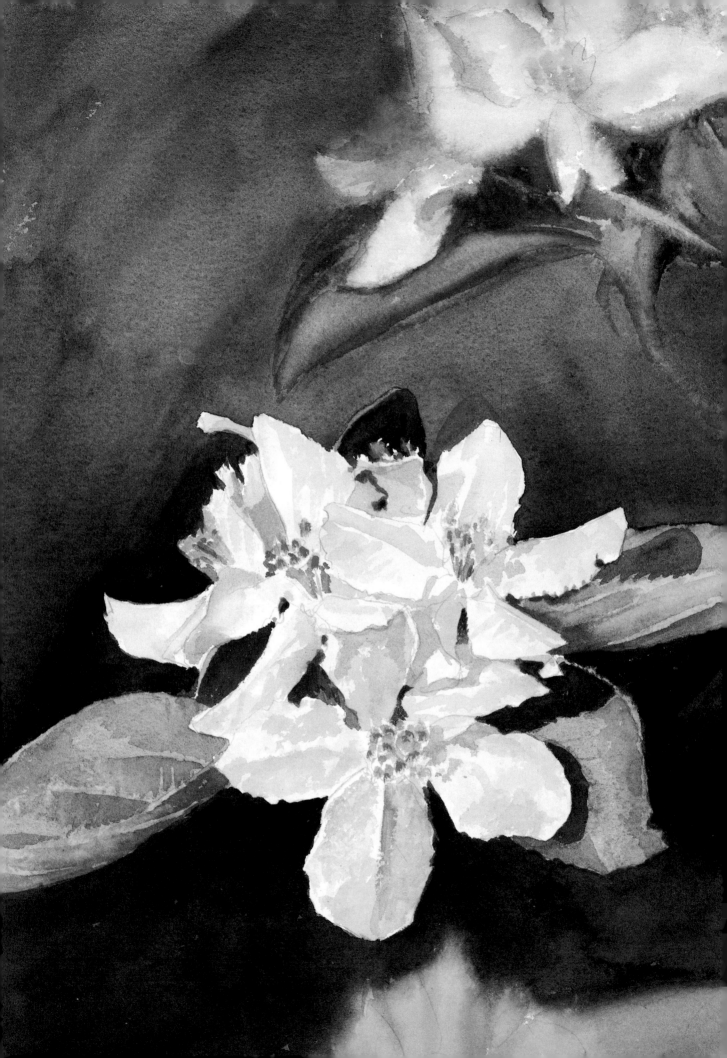

FINISHED PAINTING

Now comes the most important step—adding the delicate shadows and highlights that play about on the apple blossoms. Using very light washes and loose, fluid brushstrokes, lay in the shadows. Let bits of the brilliant white paper alone—these passages will make up the highlights. Finally, dab brilliant orange and gold into the center of each blossom.

DETAIL

In the finished painting, the lyrical lines of the drawing support the layers of wash that make up the apple blossoms. In situations like this one, when the drawing is going to play a large role in the success of a work, think through the kinds of line you might use before you begin to sketch. Were the pencil lines thicker or harsher here, they would overpower the delicate flowers.

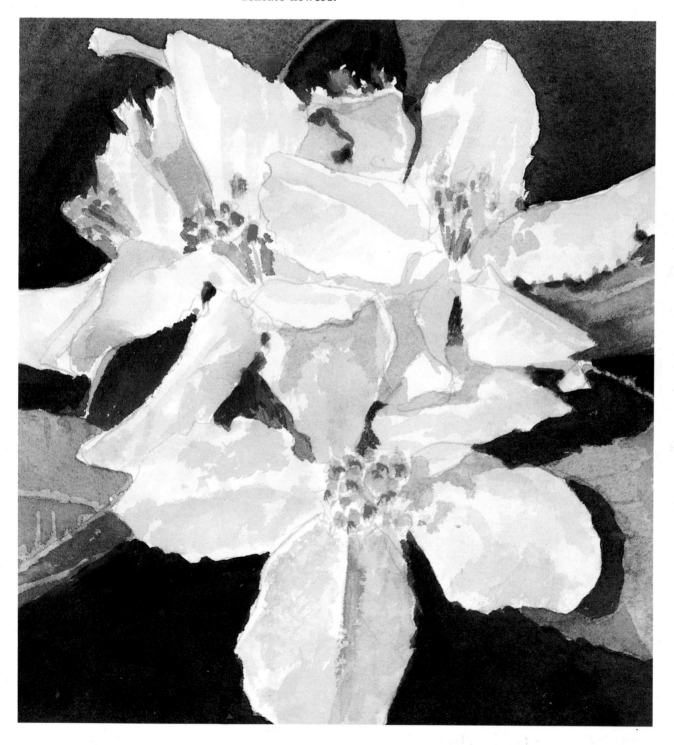

Analyzing the Colors of Familiar Objects

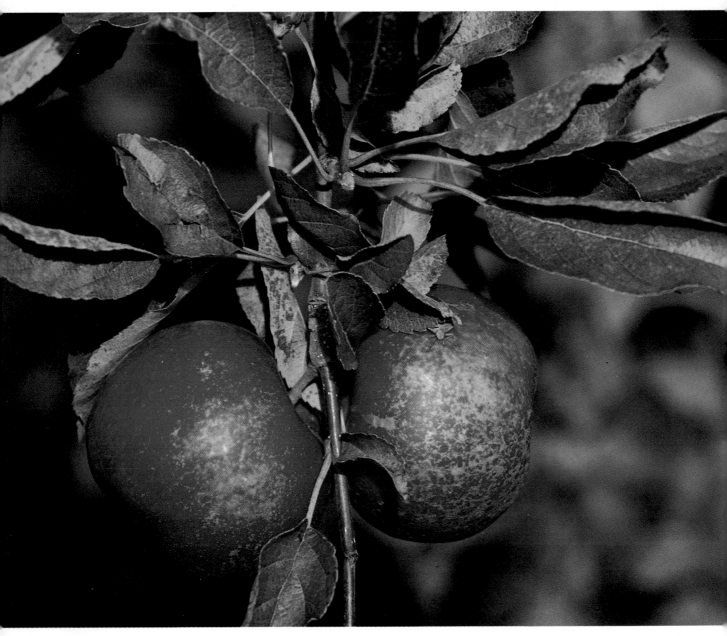

PROBLEM
These apples are richly mottled with gold, yet many people would ignore the yellow areas and just concentrate on the obvious reds. When you approach a familiar object, it's hard to come to it with a fresh point of view.

SOLUTION
Build up the apples slowly, starting with a deep gold wash. Add the red last.

Sunlight pours down on the branch of an apple tree, picking up highlights on the bright fruit and leaves.

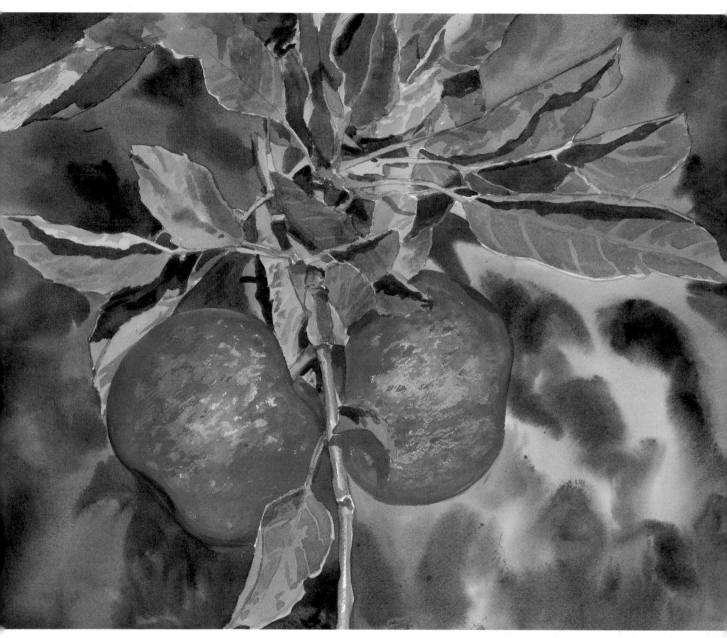

☐Sketch the scene, then wet the background and begin to drop in your color. Instead of masking out the apples, paint around them; you'll achieve a softer, warmer effect. As you work in the greens and browns in the background, keep the values darkest on the left.

Let the background dry, then turn to the leaves. Execute the lightest areas first, then gradually add the shadows. As you develop the leaves, rely on warm and cool colors to indicate contrasting areas of light and shade. Next, add a purplish wash to some of the leaves to indicate their dark, brittle undersides.

To capture the brilliant yellow speckles that run across the surface of the apples, begin by putting a pale ocher wash over the fruit. Let the wash dry, then take pure cadmium red and work in the deep red skin with a fairly dry brush. To depict the darkest, richest reds, increase the density of your pigment.

Painting a Tree Silhouetted at Sunset

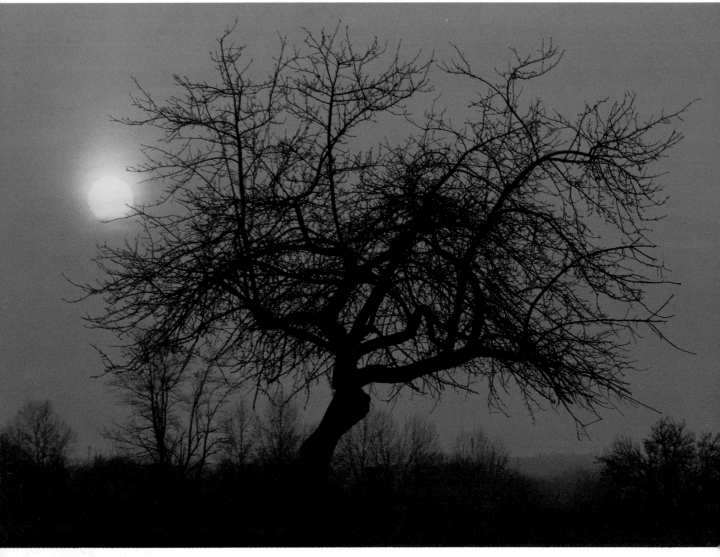

PROBLEM

Moments like the one captured here are so spectacular that it's hard to make them seem credible in paint. The setting sun will be especially difficult to capture.

SOLUTION

Surround the sun with a deep orange wash; as you move outward, make the wash progressively lighter. The point is to make the sun seem natural, not just pasted onto the sky.

Just as the sun sinks toward the horizon, an old, gnarled apple tree is set off by a deep orange sky.

STEP ONE

After your preliminary sketch, paint the bright yellow sun. Wait for it to dry, then lay in the rest of the sky with a wash mixed from cadmium orange, cadmium red, alizarin crimson, and Davy's gray. Since this strong orange appears throughout the scene, cover the entire paper. Make the wash most intense around the sun.

STEP TWO

Lay in the background, beginning with the light tones along the horizon. Here cerulean blue and alizarin crimson are blended to form a muted purple that recedes into the distance. Next, develop the grass in the foreground using burnt sienna, cadmium orange, and sepia. When the grass dries, add the distant trees with burnt sienna, ultramarine, and alizarin crimson.

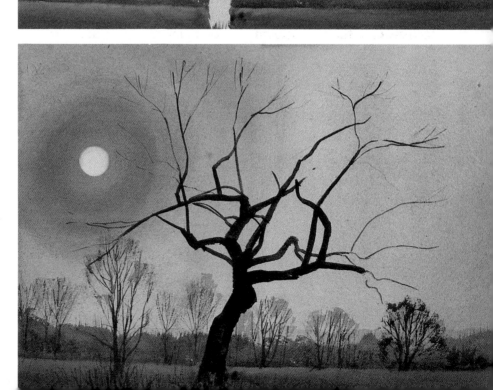

STEP THREE

Paint the tall trees in the background with sepia and burnt sienna. First, lay in their trunks and branches, then, when they're dry, apply a light wash to indicate the fine twigs that radiate out from the branches. Finally, take pure sepia and begin to depict the apple tree.

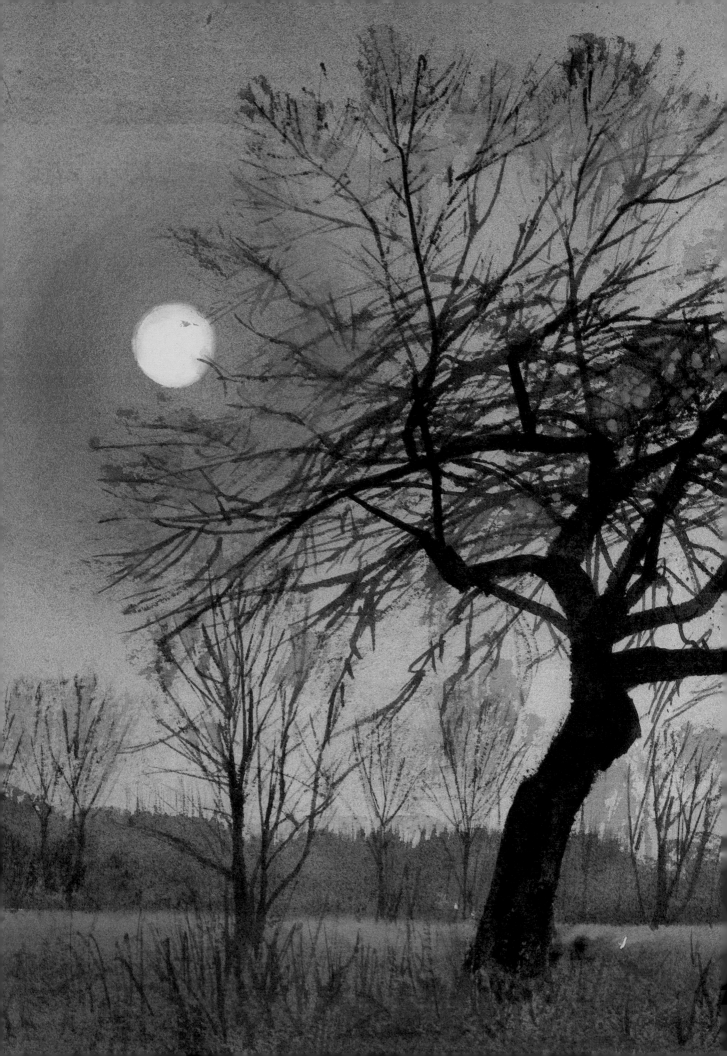

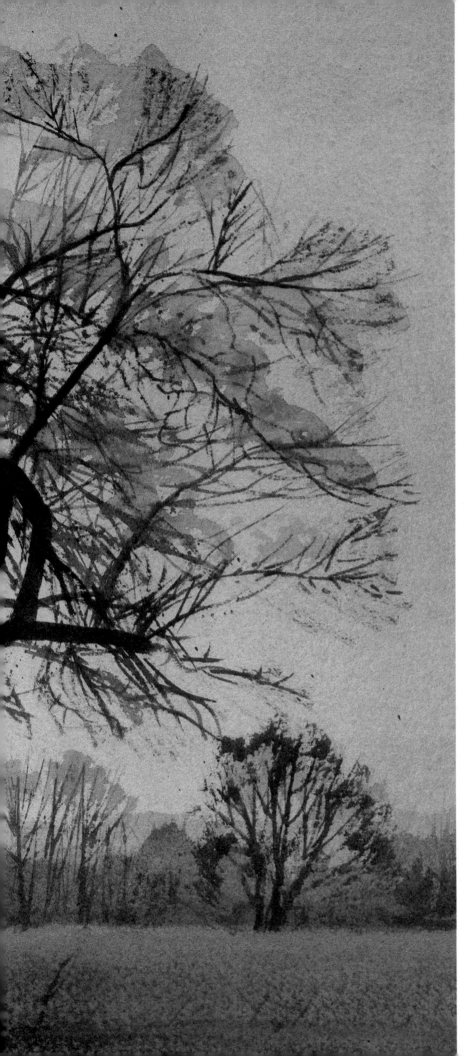

FINISHED PAINTING

Filling in the tree's skeleton proceeds in two stages. First, prepare a wash of sepia and burnt sienna and add the small branches. Use fine, rough brushstrokes; with an old tree like this, what you want to convey is a loosely organized jumble of branches and twigs. Finally, dilute the wash and lay loose passages over the minor branches to indicate the very fine, spidery twigs that lie at the tips of the branches.

Rendering a Tree Against a Stark Winter Sky

PROBLEM

After trees have lost their leaves in fall, it's hard to suggest the fine network of twigs that endures until spring. If the twigs are painted too forcefully, they'll look artificial.

SOLUTION

Don't try to paint each and every twig. Instead, lay in a light wash along the edges of the branches to suggest how the spidery twigs mass together.

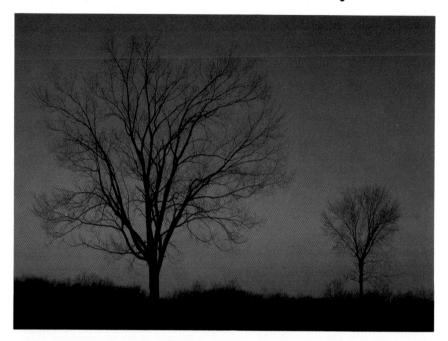

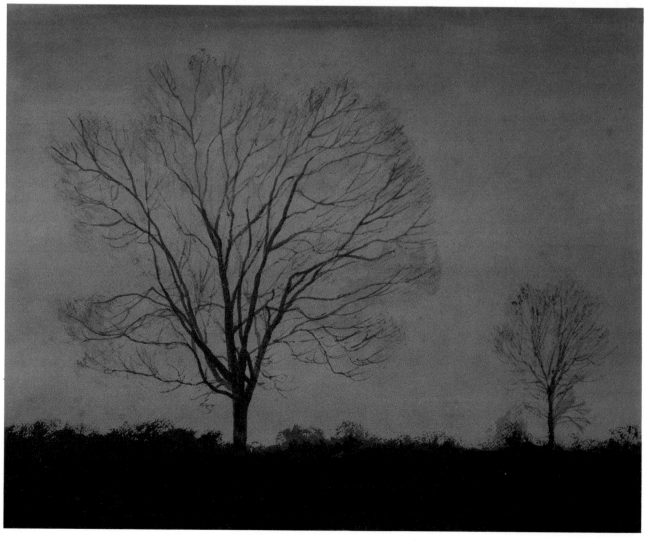

☐After a careful drawing, lay in the sky with cadmium red; to highlight the trees, darken the top of the paper and its far right side with alizarin crimson.

Next, begin to lay in the tree trunks and the largest branches with a dense blend of sepia and ultramarine. Use the same mix to render the dark, flat foreground; while the paint is still wet, take a dry brush and pull the pigment up along the horizon to create an interesting, uneven line.

Next, lay in patches of a light wash to indicate how the twigs mass together near the edges of each tree's crown. The wash should be light, but not so light that it gets lost next to the bright sky. Finally, lay in wispy, feathery strokes around the edges of the crowns.

DETAIL

The swatches of pale wash used to suggest the twigs are laid down with loose, fluid strokes, their uneven contours mimicking the shapes formed by the masses of twigs. The feathery strokes that radiate outward from the edges of the swatches of wash break up any area that has become too regular and convey the spidery feel of a tree's crown in fall.

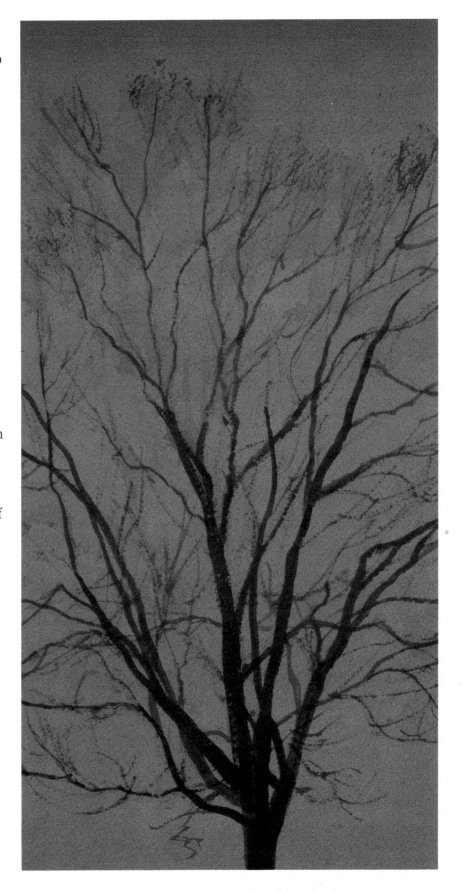

On a cold winter evening, two elms stand against a deep red sky.

Capturing a Tree at Twilight

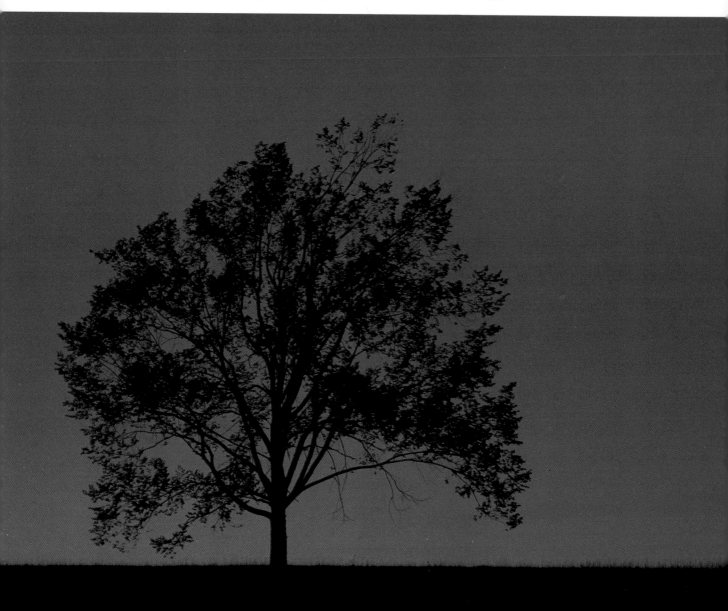

PROBLEM

In spring, when a tree's foliage is just beginning to fill in, it takes a light touch to suggest the lacy, delicate patterns that the leaves etch against the sky.

SOLUTION

Stippling is ideal for conveying the soft, delicate feel of spring leaves. Work with a fine brush, paying close attention to the patterns formed by the leaves.

Crowned with fresh spring foliage, an elm tree is silhouetted against a purple sky at twilight.

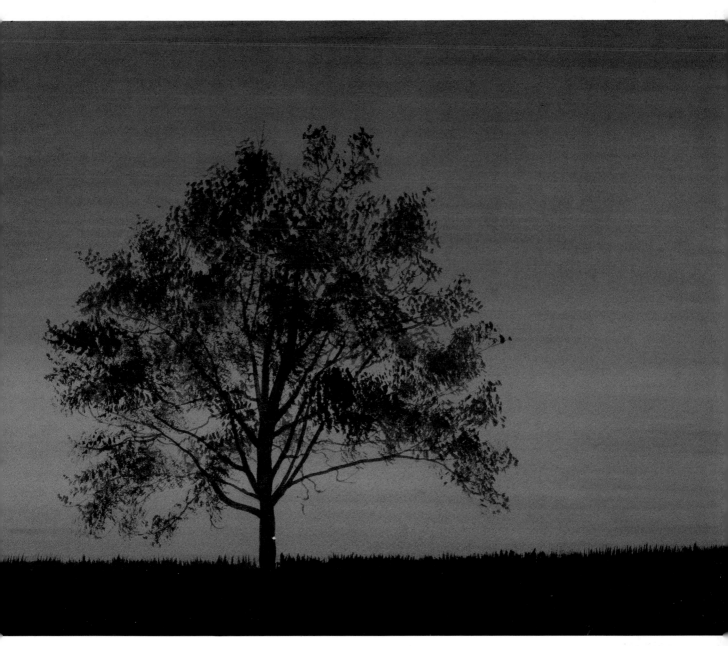

□Sketch the scene, then lay in the sky with a graded wash; use pure ultramarine at the top of the paper, then gradually blend it with mauve. When the sky is dry, paint the tree trunk and branches.

To render the leaves, take a fine brush—preferably an old one—and moisten it with pigment. Begin to dab it lightly onto the paper, constantly keeping the tree's shape in mind. When your brush becomes a little dry, keep on stippling—these lighter, rougher passages will keep the brushwork from becoming monotonous.

Finally, lay in the foreground, then, with feathery strokes, depict the grass growing along the horizon.

The pigment used to paint the leaves is fairly dense—it has to be if it's going to stand out clearly against the deepening sky. Note the lively, irregular shapes formed by the stipples; each dab has a slightly uneven edge. To achieve this effect, manipulate the paint with the tip of your brush as you lay it onto the paper.

Adding Interest to a Simple, Uncomplicated Subject

PROBLEM

Compositions made up of simple geometric forms can easily become static. If you render the conical tree and flat horizon line too literally, your painting will be dull and flat.

SOLUTION

Break up the stark, simple lines of the composition by enriching your painting with texture and detail. Concentrate on the texture of the tree's densely packed branches.

☐ After your sketch, lay in the sky with a graded wash of cerulean blue and yellow ocher, then, after the wash has dried, turn to the greens. Here all of them are mixed from ultramarine, new gamboge, and Hooker's green. With a simple composition like this one, it often helps if you limit your palette; the colors that you mix will be closely related, helping to maintain the scene's simplicity. Lay in the foreground with broad, sweeping strokes, then turn to the tree. Begin with the trunk and the scraggly branches toward the base. Render these irregular branches faithfully—touches like this break up the tree's stark shape.

For the crown, use just three values. The middle-tone green isn't really obvious in the photograph, but without it, there would be a big jump between the darks and the lights. Let bits of the sky shine through the foliage, and keep the edges of the crown lively and irregular. Finally, add exaggerated detail to the grass in the foreground and then spatter a little light green paint across it and on the tree's crown.

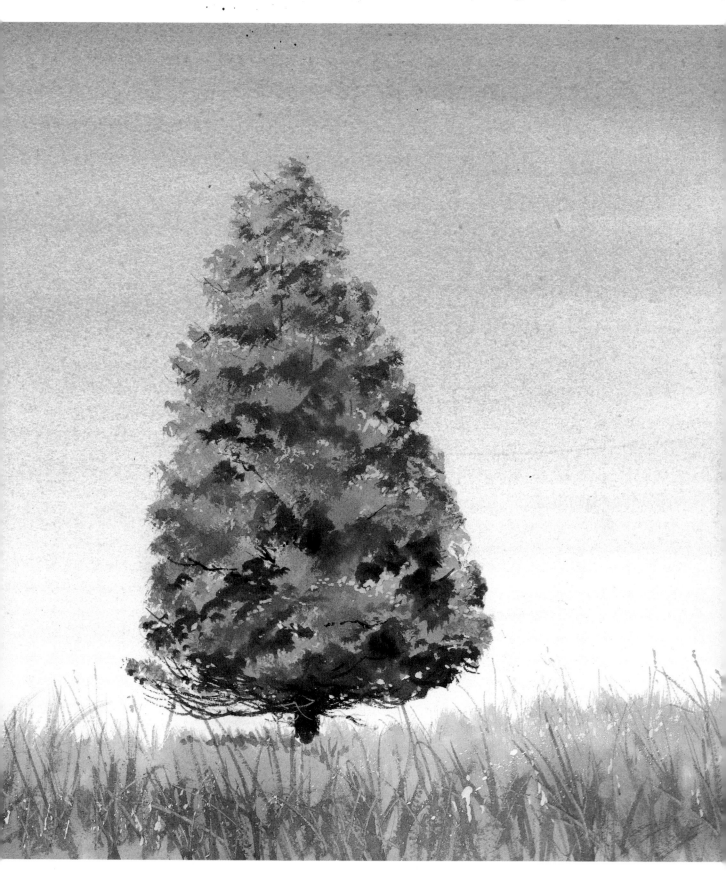

In summer, a northern white cedar stands alone in a grassy meadow.

Working with Pattern and Texture

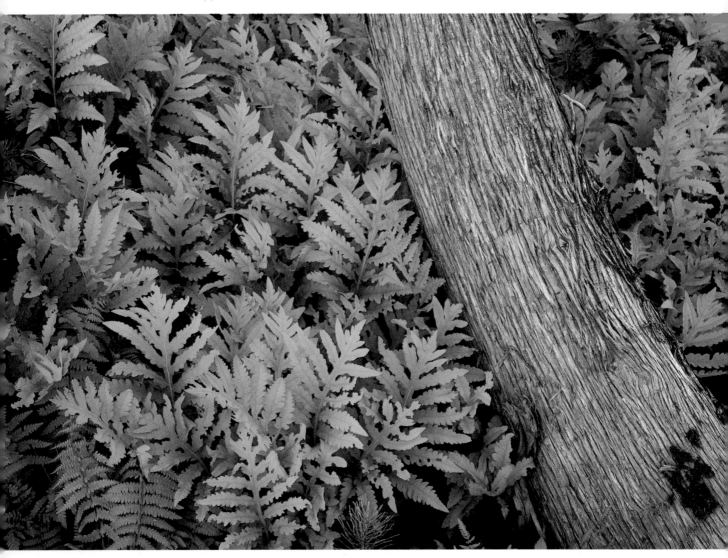

PROBLEM

The rich, lush ferns are obviously the focus of this scene, but if you treat the tree trunk too superficially it will look artificial and hard to decipher.

SOLUTION

Pay equal attention to the tree trunk and the patterns formed by the ferns. Because the ferns will be more difficult to render, execute them first.

Masses of lush, delicate ferns crowd against the curving trunk of a white cedar.

STEP ONE

Once you have finished your sketch, begin to work on the ferns. Lay in an uneven wash made up of cool and warm tones, mixing the paint after you've dropped it onto the paper. To create a focal point, use warmer tones near the center of the paper and cooler and darker ones toward the edges. Here the background is made up of Hooker's green light, lemon yellow, cerulean blue, and ultramarine.

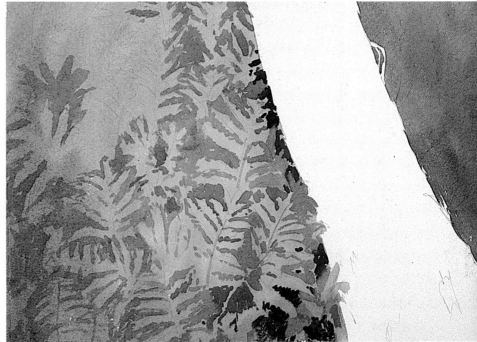

STEP TWO

Begin to build up the ferns. With two values of green—one very dark and the other a middle tone—work around the light wash laid down in step one. You are actually silhouetting the light areas of the ferns, adding the darker tones to pull out their shapes. Use the darkest value cautiously. The washes employed are mixed from Hooker's green light, ultramarine, and new gamboge.

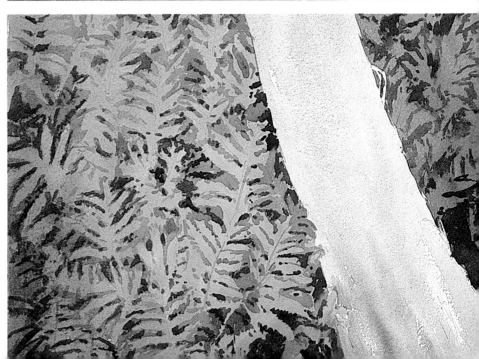

STEP THREE

Finish the background. As you move toward the edges of the paper, don't be too literal. What matters is capturing the impression the ferns create, and the pattern they pick out. The more precisely rendered ferns near the tree will concentrate attention in one area. Next, using Payne's gray, cerulean blue, and yellow ocher, lay in the tree trunk with an uneven wash.

FINISHED PAINTING

Add sepia to your palette and begin to render the trunk's texture. Small, broken, vertical strokes convey the rough feel of the bark and enhance the sweeping arc the trunk traces against the mass of rich green.

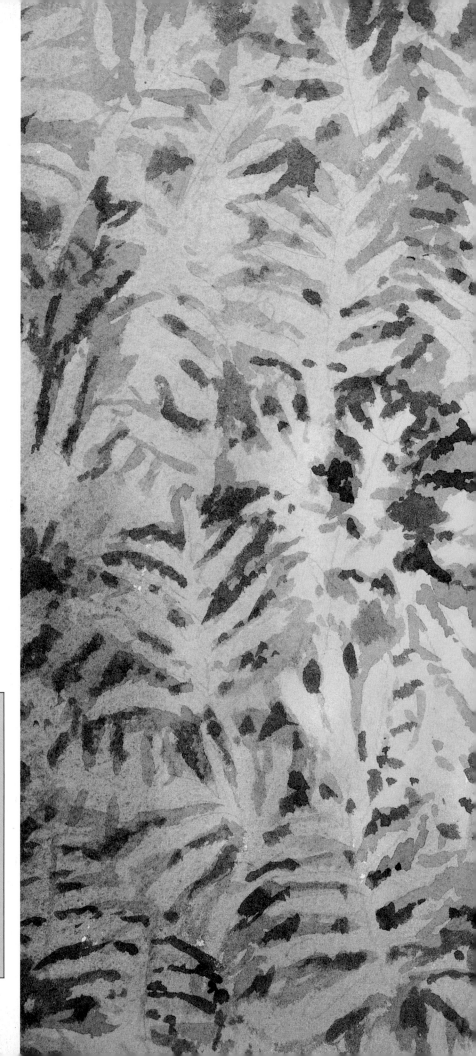

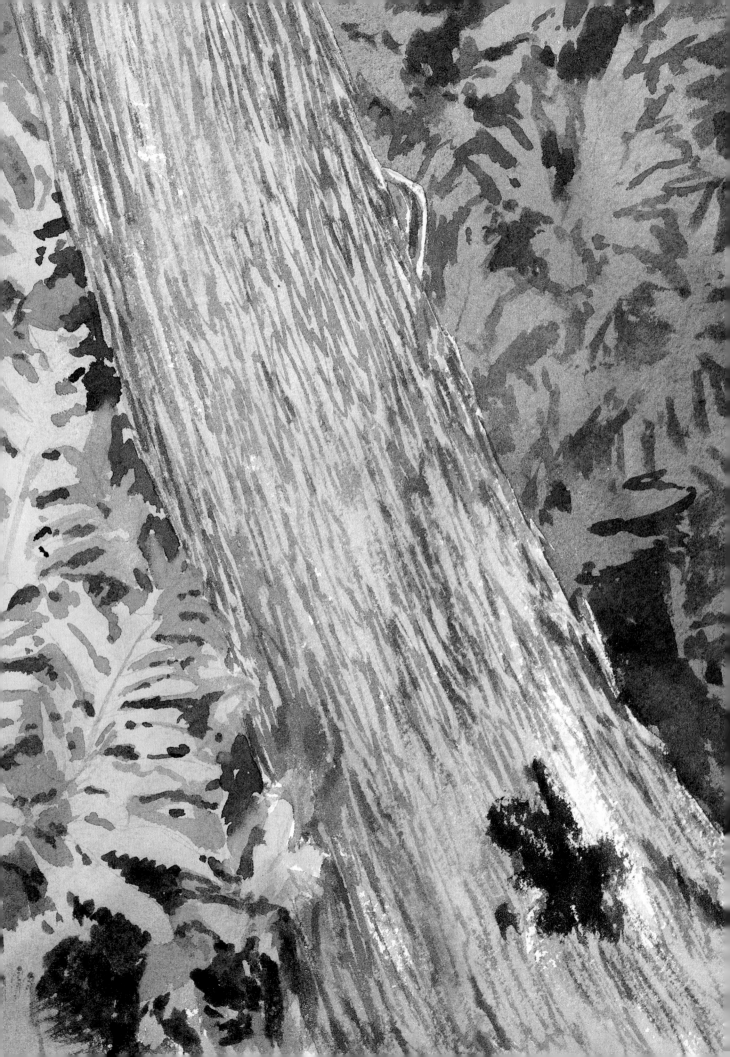

Painting a Tree Viewed from Below

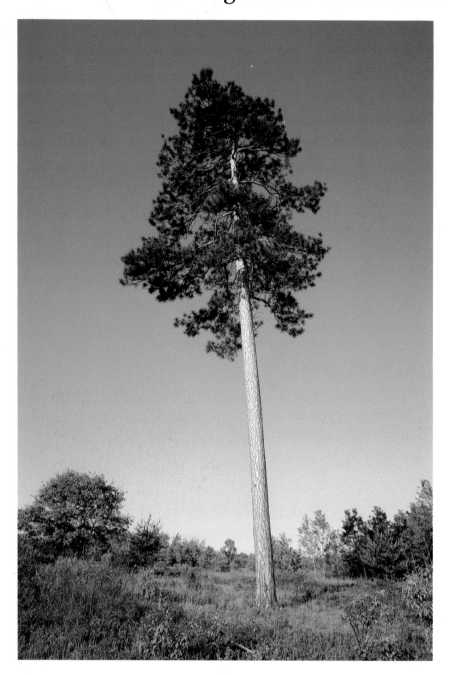

PROBLEM

A lot of the tree's power comes from the dramatic way it is set against the sky. To convey this drama, the long pale trunk has to stand out against the light blue sky near the horizon.

SOLUTION

Apply masking solution to the trunk and its spreading branches. When you remove the mask, you'll be able to adjust the values of the lights.

STEP ONE

Sketch the scene, then mask out the trunk and the light branches. Lay in the sky with a graded wash. Since it's easiest to work from light to dark, turn your paper upside down. To achieve the rich blue seen here, work with cerulean blue, ultramarine, and yellow ocher.

In late summer, a majestic red pine stands boldly against a clear blue sky.

STEP TWO
Paint the foreground. Since the tree's crown is well removed from the horizon, feel free to use a lot of lively color and brushwork; it won't detract from the tree's power. Use drybrush technique to render the tree tops farthest away, and leave some of the distant tree trunks white. The colors here are mixed from Hooker's green light, new gamboge, yellow ocher, sepia, and mauve.

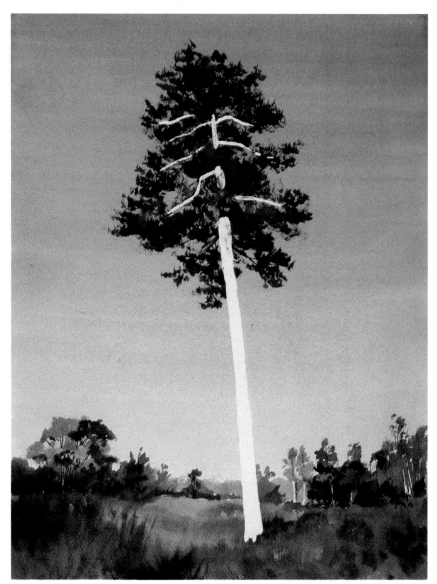

STEP THREE
Now tackle the pine. Emphasize its bold silhouette with your strokes. Take an old brush and load it with paint; use just barely enough water to keep the pigment moist. Dab on the color, working outward from the center of the tree. Try to achieve rough, irregular strokes that grow faintest toward the crown's edge.

FINISHED PAINTING (overleaf)
Remove the masking fluid and lay in the trunk. First, put down a pale wash, then add a darker tone along one side to portray how light strikes its surface. Finally, spatter a little gold paint on the immediate foreground.

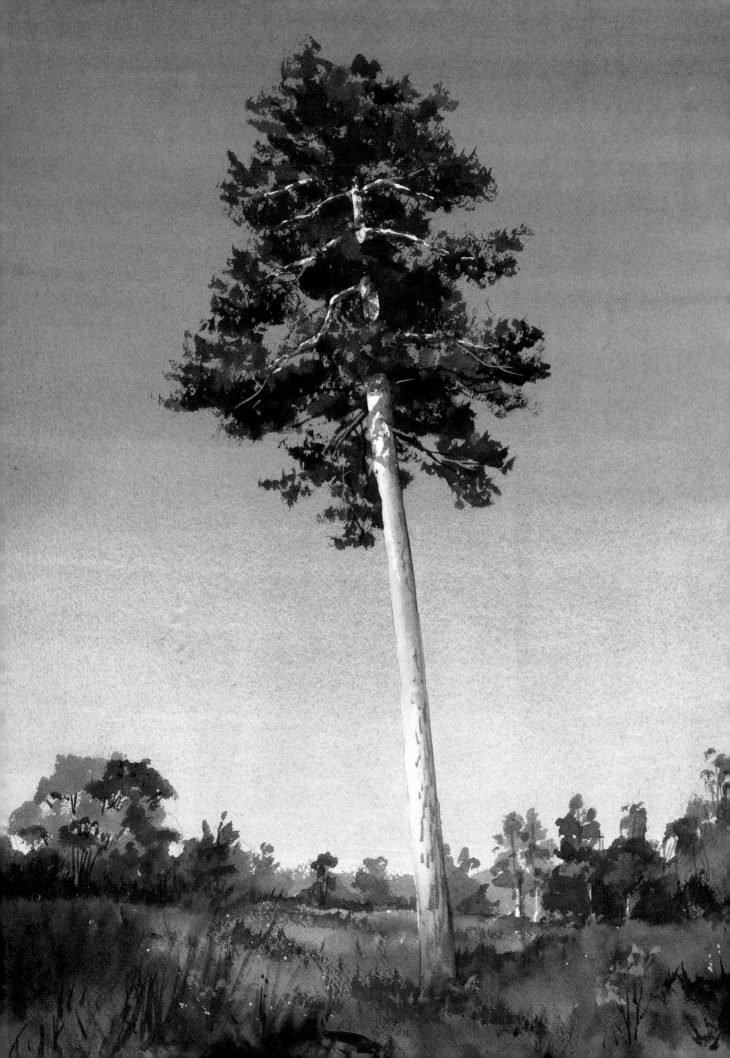

Looking for Pattern in an Intricate Closeup

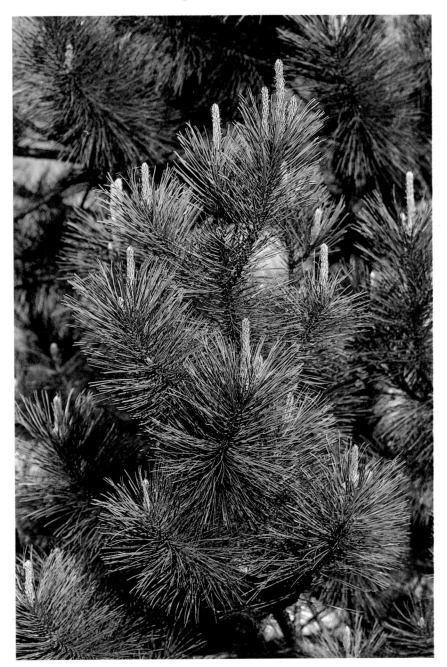

PROBLEM

When a closeup has as much detail as this one does, you can lose your way in it. Find something to hang onto right away, or your painting will be a mass of details without any structure.

SOLUTION

Look for the simple patterns formed by the middle and dark values, then emphasize them to organize your painting.

STEP ONE

Sketch the basic lines of the composition, then analyze its structure. You'll see that the tall branch tips form a simple S-shaped pattern. Begin to lay in the background—the blues of the sky, the middle-tone greens that coil throughout the composition, and the mauve trunks at the far right.

Bundles of slender green pine needles spring out from scaly brown branches.

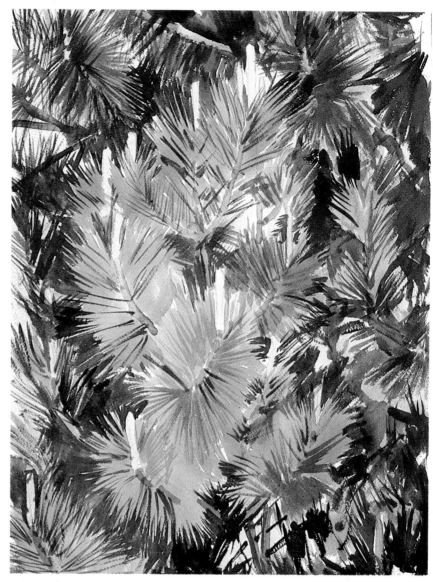

STEP TWO
Start adding the darker pine needles on the left. To keep them from pulling attention away from the S-shaped pattern you've established, minimize their detail. Keep your stokes simple and, in some areas, mass them together so densely that they look almost solid. Before you go any further, paint in the branches and their tall tips.

STEP THREE
Develop the rest of the background. Cluster the darkest areas at the top of the painting and at the far edges and continue to simplify your brushstrokes. As you paint, follow the directions in which the needles grow.

FINISHED PAINTING
Texture the branches with a deep brown wash, then adjust the values slightly by darkening portions of the background.

Balancing Dramatic Clouds and Strong Color

PROBLEM
The glorious cloud formations that fill the sky have to look fresh and unstudied. Their undersides are dark and shadowy, and if they're not handled lightly, the sky will seem heavy and dull.

SOLUTION
Execute the sky first and, if you lose your spontaneity, start over again right away. As you work, constantly soften the shadowy areas on the clouds with clear water.

Spectacular clouds sweep over a golden autumn landscape punctuated by spruce trees.

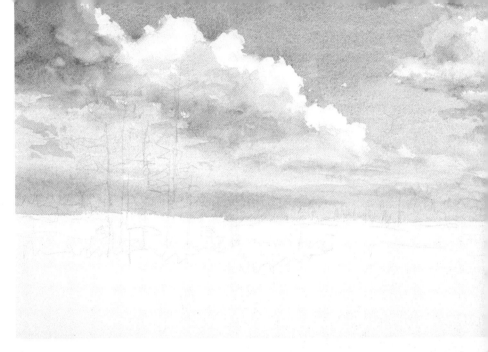

STEP ONE

In your preliminary sketch, very lightly draw the shapes of the clouds; use your drawing as a rough outline when you begin to paint. Lay in the clear blue sky in the background, then tackle the formations. Work from light to dark, softening all the transitions betweeen areas with clear water. Finally, lay in a few small clouds right over the blue sky.

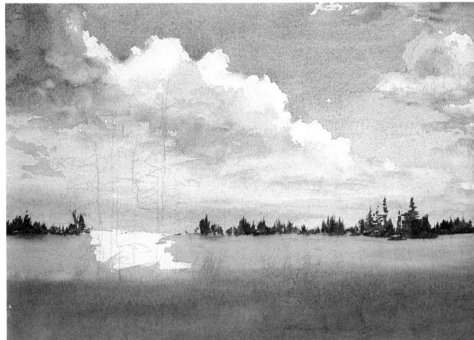

STEP TWO

Develop the trees that lie along the horizon line. Don't make them too pale; the forceful sky has to be balanced with fairly strong color throughout the landscape. Next, using rich, warm tones, develop the foreground. For the time being, just worry about its basic color; detail will be added later.

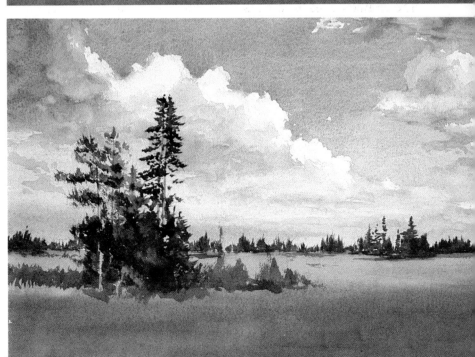

STEP THREE

Add the trees and the shrubs in the foreground. First, use a pale gold wash to render the spruce trunks; then concentrate on their foliage. Here a rust wash applied in the center of the cluster of trees holds them together and relates them to the field beyond. Next, build up the leaves, using short, scraggly strokes and concentrating on how the branches move out from the trunks.

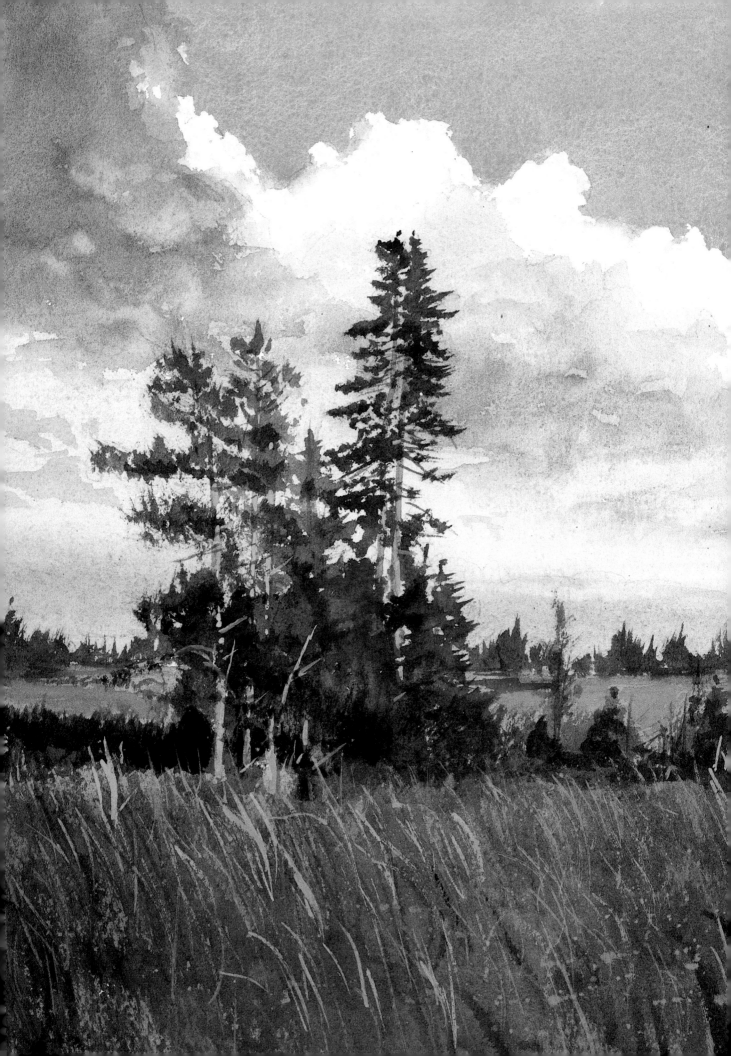

FINISHED PAINTING

For the final step, add detail to the immediate foreground. Pack the area with thin delicate strokes to get across the feel of wind sweeping across the grass. Work with several shades of orange, gold, and brown; finish by spattering a few irregular touches of orange across the grass in the direction that it's moving.

ASSIGNMENT

Throughout this book, a big part of the work—composition—has been done for you. Now it's time to strike out on your own.

For the next few weeks, carry a sketch pad with you whenever you go outdoors and look for interesting subjects. Keep them simple at first; there's no easier way to get discouraged than to tackle an overly ambitious project. For example, don't choose an intricate forest scene set around a waterfall; instead, focus in on two or three of the trees.

Of course you'll want to try your hand at some panoramic landscapes, but don't forget to look for the small, unexpected details that can make painting trees endlessly fascinating. Search out the patterns their leaves form, the rich texture of their fallen leaves and cones, and the delicate lines of their blossoms.

You'll probably want to paint a lot of the subjects you find. That's fine, but when you're in a hurry and don't have time to execute a painting, keep on drawing and learning to see.

Index

Editorial concept by Mary Suffudy
Edited by Elizabeth Leonard
Designed by Bob Fillie
Graphic production by Ellen Greene
Text set in 11-point Century Old Style